PHOTO ADVENTURES FOR KIDS

Solving the Mysteries of
Taking Great Photos

Anne-Laure Jacquart

Illustrations by Thomas Tessier

rockynook

Photo Adventures for Kids
Anne-Laure Jacquart
www.annelaurejacquart.com

Editor: Jocelyn Howell
Project manager: Lisa Brazieal
Marketing manager: Jessica Tiernan
Translation: Marie Deer
Graphic design and layout (French edition): Nord Compo
Layout and type (English edition): Petra Strauch
Cover design: Nord Compo

ISBN: 978-1-68198-142-0
1st Edition (1st printing, August 2016)
© 2016 Anne-Laure Jacquart
Photographs and technical drawings © Anne-Laure Jacquart
Illustrations © Thomas Tessier

Rocky Nook Inc.
1010 B Street, Suite 350
San Rafael, CA 94901
USA

www.rockynook.com

Distributed in the U.S. by Ingram Publisher Services
Distributed in the UK and Europe by Publishers Group UK

Original French title: Mission photo pour les 8–12 ans
© Groupe Eyrolles, Paris, France

Library of Congress Control Number: 2016930704

This book is printed on acid-free paper.
Printed in China

Dear photo detective,

We need your help with a very important mission: solving the mystery of photography.

For several centuries, large numbers of experts have tried their hands at the problem, but they were blinded by technique and often became prisoners of their cameras, so most of the time all they did was scratch the surface of the problem. A lot of grown-ups have forgotten that if you want to create really cool pictures, having a nice camera is not enough; the most important thing is to know how to use your eyes, head, hands, legs, and heart!

And now that we have figured that out, we adult experts have made an important decision: since we have bumped up against our own limitations, we are passing the baton on to you.

So now it's up to you, kids—the torch of photography has been passed on to you...

...along with the honor of attempting to take on one of the greatest challenges of all time: deciphering the riddle of the creation of images in order to breathe new life into photography.

Today, we are putting our best young investigators on the case and I am happy to announce that you are one of them.

In order to solve the mystery of photography, you will have to carry out a lot of investigations, solve unfathomable riddles, and demonstrate all of the insight you are capable of.

Will you be able to find the right strategies so you can successfully complete every mission I send you on?

Will you have the patience and perseverance that you need in order to take the pictures that will reveal the key to the mystery, little by little?

I want to thank you for having agreed, by opening this book, to meet this serious challenge. I am positive you will be equal to the mission that has been entrusted to you.

All of the photographers around the world are counting on you.

I wish you happy reading and great pictures!

Anne-Laure Jacquart

Contents

Let's Discover Framing . 11

A New Weapon for Framing 33

Framing in Three Dimensions 47

A few words for the grown-ups

Initiating children into photography

An exploration of the creation of images

The goal of this book is for the child to explore the process of photography. The young reader will discover that framing and composition can allow him or her to **truly control the content of images.**

This book covers important topics like choosing a subject, knowing how to move the camera and move in space in order to capture one's environment, and exploring the possible interactions between a subject and the frame. All of these concepts are dealt with in a manner that is progressive and playful, so that the reader can discover for him- or herself what photography does and the pleasure of creating images.

The challenge? To learn and to understand: to take "better pictures."

In the context of this process of exploration, working by trial and error, implementing a variety of strategies in order to find the best one, **the image that is created is not an end in itself but rather a way to move forward.**

As a result, this book has no intention of teaching the children and adolescents who read it to make pretty postcards, or even photos that are considered "successful" according to our adult criteria.

Therefore, I would encourage you not to expect your child to "improve" his or her photos in the way you might expect at first, or to produce images that are less odd than the ones she or he has taken so far. In fact, it should be just the opposite! I really hope that this book will push young readers to take even more surprising pictures than before as they experiment with images!

Support, encourage, accompany!

For these reasons, I recommend that you do not express any value judgments about the photos that your child takes, even if you find them disorienting. Be encouraging and curious about the child's photographic process at all times. Instead of saying "Oh wow, that one really didn't come out at all, did it?" or "What a bizarre picture," show your interest and ask the child questions like, "That's interesting! What made you want to take that picture?" "What subject did you choose for this one?" or "How did you go about taking a picture of that?"

You may be very surprised to discover that there are serious photographic intentions behind pictures that, to you, look like they were framed completely by hit or miss.

This affirming, thoughtful process is what will make your budding photographer into an accomplished artist in no time at all! Patience! Give the child the chance to digest what he or she has learned and understood and put it all into plenty of practice. The "successful pictures" will follow; you can be sure of that!

Which camera?

It's natural for you to be concerned with the technical aspect of photography, but at this stage, the child is not going to be concerned with adjusting apertures and exposure times or feeling the need for complicated features. So just about any camera (even a smartphone) will be just fine, as long as it can produce photos of a quality that pleases the child.

To begin, you should be thinking in terms of looking through your cupboards for a small digital camera that nobody is using!

Oh, come on, this stuff isn't for us. Let's turn the page quick so we can get started on our adventure!

Picture quality

Producing satisfying images—with good colors and sufficient contrast, even in low light conditions—will motivate the child to stick with photography. Look through online forums and websites that compare the image quality of various cameras (www.dpreview.com) in order to get some ideas!

Useful features

Finally, make sure that the model you choose has the features listed on the following page, and specifically check whether it makes it possible for your child to do the following:

 – photograph in "flower mode" (macro mode) to take sharp closeups of small subjects;

 – turn the flash function on and off easily, so that the user can choose whether to use flash rather than having it just be something that happens to them;

– adjust the lighting of the images by adjusting the exposure (with a gradual adjustment to lighten or darken the picture).

A child who is comfortable with the camera

Take a quick look at the design and ergonomics of the camera. A child should be able to hold it comfortably and use it easily. It shouldn't be too chunky or too heavy. A well-designed compact or hybrid camera ought to be perfect!

If you are buying a new camera, let your child try it out, if possible. (Or if you buy a camera online, make sure there is a good return policy.) Can your child hold the camera well? Does his or her index finger fall naturally on the shutter button?

3

Basic tips for taking good pictures

Before you start off on your first "picture hunt," make sure you are well prepared to go into battle! These initial challenges and tips will start you off on the right path.

Taking care of your camera

– Always put the camera's neckstrap around your neck or the wrist strap around your wrist.

– Do not run with your camera. Put it down or in a case when you are running.

– Find a little pouch to put your camera in. Don't just put it loose into a bag!

– Always put your camera down at least 8 inches from the edge of the table so that there is no risk of it falling.

> My camera doesn't have a big wheel or any of these settings, but that's no big deal. It won't keep me from carrying out my mission! Meet me on page 6!

> Harry Potter has his magic wand. Spiderman has his special suit. And I have my amazing camera. I love it!!

Using your camera correctly

Do you see the question marks in this picture? They mean that I don't know where these settings are on your camera, or whether your camera even has them at all!

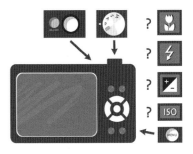

▶ It's your turn! Pick up your camera.

Look for each of the settings, either on the camera's knobs or in the menu. If you need to, consult the user's manual or ask an adult to help you. Check out the explanations on the next page to see what each setting is for.

If a setting does not exist on your camera, it's no big deal: go on to the next thing!

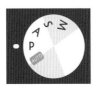

Turning the camera on and off

Turn the camera on with the little on/off button and then push the large button to take a picture!

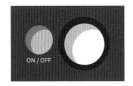

Set the large wheel to P

If you have a large wheel like this on your camera, set it to P. This will help for the other settings!

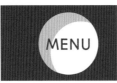

The menu

The menu button lets you adjust certain settings. Look for the settings symbols listed on the next page near the knobs or in the menu!

Macro mode

In order to take closeups (of things like jewels, candy, shells, feathers, flowers, small models...) think about choosing macro mode ! The camera will then know to focus on what is close to it.

Be careful, though, and remember to deactivate (🚫) this setting when you want to take a picture of something farther away!

Brightness setting

Sometimes, the camera takes a picture that is too dark or too bright—what a pain! Fortunately, there is a way to deal with that. The ➕➖ symbol allows you to put a kind of ruler on the screen. In order to brighten a picture that is too dark, move the cursor to the right (or upward). And in order to darken a picture that is too bright, move it to the left (or down). When you're done, don't forget to put the cursor back in the middle!

```
‾·····▼·····⁺   ‾·····▼·····⁺
 ⟵│               │⟶
  darker          brighter
```

The flash

The flash can help you take sharp pictures when there is not a lot of light by producing a flash of bright light. This helps the camera see what you are photographing better. You should mostly rely on the automatic flash ⚡ᴬ. But if at some point your flash photos seem ugly or strange-looking (white in some places, black in others, with large shadows), choose (🚫) to turn off the flash! Later you can go back to the automatic flash ⚡ᴬ if you want to!

ISO settings

The ISO setting can also help you take sharp pictures when it's a little dark. Look for this setting in the menu or among your knobs and buttons! If it isn't there, that's great—that means you are already in automatic ISO! But if you do have the setting, don't set it on one of the big numbers; just set your camera to "automatic ISO." Once that's done, you don't have to touch it anymore.

▶ Have you found one of these settings? Good. Now try to figure out how to ADJUST it.

− If the setting is adjusted with a button, push it several times. Does that turn it on or off?

− If pushing the button doesn't work, once you have chosen the setting, try to turn the control knobs that are probably on your camera.

− And finally, the left and right buttons on the wheel on the back of the camera can sometimes be used like arrows to move around in the menu on your screen. Try operating them to find out!

▶ Are you all set? All right then, here is your first assignment!

If your camera doesn't have these settings, then you're excused from this assignment, but this is the only time you'll be let off the hook like that. If you only have some of the settings, follow these directions as far as possible.

Take these pictures using the explanations given on this page.

− A picture of a fruit or a vegetable, darker than what the camera would take on its own.

− A closeup of a flower using the macro mode.

− A view of the living room taken with a flash when it's dark.

− The same view of the living room in the evening but without the flash. The picture might be blurry (see page 6)!

− A picture of a flower or a plant, brighter than what the camera would take on its own.

To take a good picture: move, then stop!

It's a very good habit to move around before you take a picture. But once you've found the picture you want to take, it is important to move only when you have to; otherwise, the picture will change and it might become blurry if you move while taking the shot! Here is what you need to do:

1. Move around to find the best view of your subject.

2. Have you found the picture you want? STOP!!! Act like a statue!

3. Push the button to take the picture and DON'T MOVE.

4. Wait a second... Okay, good, now you can move again.

▶ Train yourself to stand as still as a statue when you're taking pictures.

Take a picture of a red object, a picture of your room, and a picture out the window, each time holding very still before you push the button.

The issue of blurry pictures

Yeah, well I really like blurry pictures! I think they're totally stylish!

If you take pictures in the late afternoon or evening when it's a little dark outside, they will sometimes turn out a little blurry. Grown-ups often get all worked up when a picture is blurry, but we really don't have to be all anti-blurry like they are!

If you don't like it when your pictures turn out blurry, here are some tricks to help you! To fight against blurriness, you have to avoid movement:

– Think about the statue technique! Take the picture two more times, holding absolutely still for a really long time each time.

– Hold your arms tight against your body and keep the camera close to you; don't hold it out at arm's length! If you're looking through a viewfinder, you can press the camera against your face.

– Try to hold your breath right before you push the button.

– Lean against a wall or prop the camera up on a solid surface.

– If your subject is something that might move—like a person or an animal—try to photograph it when it is standing still.

I'm standing as still as a statue, with my arms tight against my body. I'm holding my breath and snapping the picture of the cat just at the moment when it's not moving. I think this time the picture will be sharp!

You can also use light to fight against blurriness:

– Take your pictures outside.

– If you're inside, take your pictures near a window. But make sure you only get the subject and not the window!

– Zoom back out if you had zoomed in. Take a wide shot, or better yet, move closer to your subject.

▶ Here is your assignment!

– Take a blurry picture of a person in the evening when it's dark out. Did you remember to deactivate the flash (see page 5)?

– Try to take a sharp, in-focus picture of a tree or a staircase, still with no flash and when it's dark, following my suggestions.

Briefing papers

These initial instructions will help you to carry out your investigation and fulfill your mission. This is how things are going to happen.

In search of investigations

This book is full of investigations to carry out, riddles to solve, and challenges to respond to! Each activity will allow you to collect clues, make deductions, and develop new strategies for making your pictures better and saving photography.

Page after page, we are going to study different pieces of photographic "evidence," in other words pictures with issues that will help us to make sure we are on the right path.

From one page to the next, in order

I have set things out for you so that you can solve the mystery, little by little. Therefore, it is very important to read this book in order and to make sure that you carefully carry out each activity before you turn the page! If you like, you can use your white cardstock frame (see page 9) as a bookmark so that you can keep track of how far you've gotten.

Don't be afraid to leaf through the pages of the book that come BEFORE your bookmark sometimes, and to go back and redo the activities that you liked or the ones that seemed hard to do, reread some of the passages, or even just look at the pictures.

Everything that comes AFTER your bookmark, on the other hand, should stay secret for as long as possible!

A long-term mission

Don't be in a rush to move forward through the book. Solving the mystery of photography is not something you can do in three days!

Take the time to look at the pictures, think about your answers to the riddles, and refine your strategies. And take breaks from your reading, of course, to take pictures. Don't hurry! It would be even better if the book could keep you company for several weeks.

Too easy?

If you were already taking pictures every now and then before you got this book, some things in here will probably seem easy to you at first. But watch out! Stay focused on your mission, even when it isn't all that hard, because later, ha ha, it will be a different story altogether!

You will see that when the clues start coming together like hundreds of puzzle pieces and you have to implement several strategies at the same time in order to carry out each mission, you won't be sorry that you paid attention.

Sometimes I have a tendency to hurry, but this time, there's no way!!! I promise to be focused and brave so that I can fulfill my mission!

Action plan

This labeled diagram should help you find your way around the pages of this book.

The "Let's investigate" sections will challenge you and allow you to collect the evidence you need to unravel the mystery.

Deductions and strategies. The evidence that you collect during the activities will allow you to make certain deductions and even develop new strategies. A strategy is nothing more than an action plan for taking great pictures!

The picture quests are photographic challenges for you to take on with your camera in hand! Follow the instructions carefully to avoid traps and conquer your enemies. The "basic tips for taking good pictures" on pages 4 through 6 will help you be ready to go when you start the very first "picture quest."

The ▶ symbol will show you when you need to take action. Answer all the questions before you look at the solution! And why don't you cut a few pieces of paper in half and fold them to make a little "investigation log book"? You can use it to write down the answers that you might otherwise find hard to remember.

The answers and solutions to the games are written upside-down. Don't turn the book around to see them until you have carried out the whole activity yourself!

Your friends and guides! Fortunately, you won't be carrying out your mission alone. There are friendly pals who have volunteered to come along with you and help you out on this big adventure!

Hints! For some of the activities, there is a "Hint" hidden on the page. Only look for it if you can't find the answer without it, of course!

 Let's investigate

 Further investigation

 Deductions

 Considering the evidence

 Strategy

 The secret weapon

 Now you frame it

 Picture quest

Now you frame it!

Oh, yes, it's just like when I take pictures!

The "Now you frame it" activities will allow you to get plenty of practice before you take your "real pictures."

Cut out the white cardstock frame at the back of the book. When I ask you to, you'll lay the frame over the book in such a way as to solve the riddle!

1. Read the instructions carefully to find out which "photos" you need to take with your frame!

2. Place the cardstock frame over the book in such a way as to "frame" the right image.

3. Then I'll show you the pictures I have taken, also by laying the frame over the page.

Sometimes my pictures might be a little different from yours but that doesn't necessarily mean that yours were wrong, of course! When you read the explanations, you will be able to figure out whether your pictures were also a good solution to the puzzle.

Once you have seen the answers, don't hesitate to go back to the scene that needs framing on the previous page in order to frame the pictures the same way I did or to find new ways of doing it yourself.

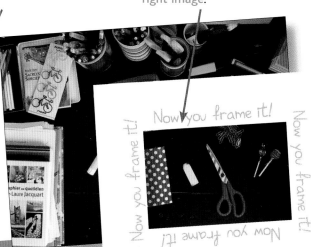

Here are a few instructions in case you need to make a new frame:

Find a piece of cardboard and draw a 5×7-inch rectangle in the middle of it using a ruler and a protractor or a T-square. Cut out the inside of this "window" with scissors or a box cutter (be careful not to hurt yourself). And there you are, you are ready to "frame!"

Are you ready for the big adventure?

On your mark...get set...GO! The mission is underway! Our job is to collect as much evidence as possible about what it is that makes up a successful photo.
Every game, every investigation, every photo quest, every little riddle will be a chance for you to collect one or more clues that, when combined, will make up your evidence. The clues that result from each of your assignments will be like pieces of puzzle, and once you put them all together, they will let you rediscover photography's core identity.

Now let us dive right into the heart of the matter with your first assignment, which is no small thing! I won't say anything more...

So, are you coming with us?

All right, here we go. Operation Photo has begun!

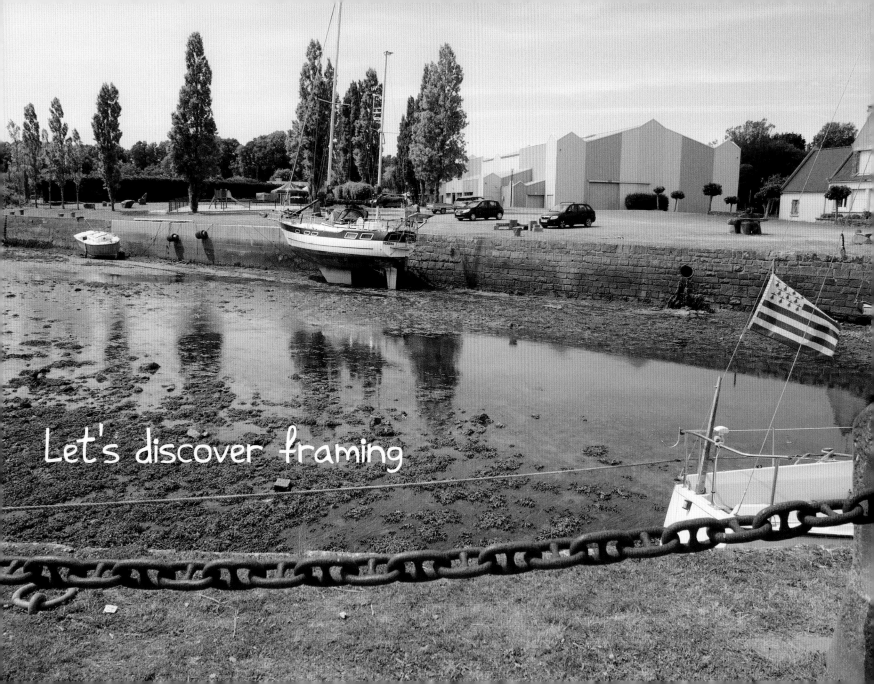

Let's discover framing

Help! Messy photos!

Let's investigate. The lost subject

Here is the first piece of evidence that we are going to examine. I hope it will lead us to discover a lot of clues!

▶ Observe this photograph carefully.

1. What do you think I was trying to show when I took the picture?

2. List absolutely everything, every single thing, that you see in the picture, including pipes, strings, and anything else. Try not to leave anything out!

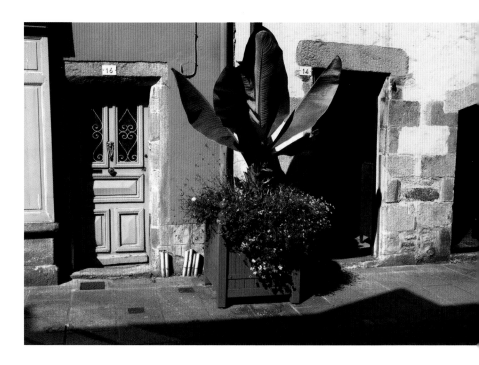

1. The main thing that you see is the banana plant and the houses, right? Me too. That's really annoying because as a matter of fact, what I wanted to show was the little pink figurine on the door.

2. Oh boy, there are so many things! In this picture, I see: a banana plant, a blue flower planter, pink and white flowers and their green leaves, a stone wall, a pink wall, a green door, part of a green shutter, the number 16, a cable on the pink wall, some pipes between the green door and the green door frame, the stone frame around the green door, a gutter between the two houses, the number 14, a large stone above the open door, a piece of furniture that you can sort of make out through the open door, the ground with a shadow on it, a small blue drain cover and three other brown drain covers, and I'm sure there are lots of other little things that I have left out! Phew!

Deductions. Let's collect our clues

Don't you think there are really just too many things in this picture?! What a hodgepodge, and what a chore to have to list everything!

In fact, what I wanted to photograph was the pink figurine on the green door (did you notice it?!), but I don't think that it worked very well.

I wanted the figurine to be my subject—that's what we call the part of the photo we are most interested in. But in this picture, you barely even see it!

Well, let's not get discouraged; instead, let's review where we are at the beginning of this investigation.

▶ From the sentences below, choose the three clues to solving the mystery of photography that the picture allowed you to collect:

A. A picture is better when its subject is nice and visible.

B. A figurine is not a good subject.

C. When there are too many things in the picture, the subject gets lost in the hodgepodge.

D. If you don't really know what the subject is, then the picture does not quite work.

E. Nobody cares what the subject is.

Our investigation is getting off to a good start! We already have a lot of evidence!

Our three new clues are sentences A, C, and D.

Strategy. The subject in a starring role versus messy photos

When you try to show too many things in a picture, you don't end up showing anything really well. The interesting elements are lost in the middle of everything else!

I call these kinds of pictures "messy photos."

And you will have figured out by now that messy photos are our enemies!

Fortunately, choosing our subject well and letting it be the center of attention will help us to fight the hodgepodge.

So this is going to be your first strategy for protecting photography: in order to take a successful picture, first choose your "starring subject"!

Decide which of all the things you see is the most interesting element and make it the star of the picture! Your starring subject needs to be cool and you have to be able to see it well in the picture.

Now look at the new picture that I took of the little figurine!

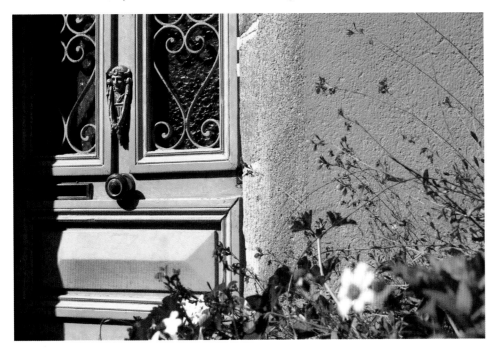

Oh, yes! I really like it when the picture is more "zen"! This is great!

This picture is much nicer because I kept only the most important elements.

▶ Which of the following elements did I decide to keep in the picture?

- the banana plant
- the blue planter
- the drain covers
- the flowers
- the green door
- the pink wall
- the gutter
- the figurine
- the ground

Whew, it's nice to have a little bit less of a jumble, isn't it? And now you can see my starring subject!

I only kept four things: the flowers, the green door, the figurine, and the pink wall.

aking the subject the star

Considering the evidence.

What is the main subject of the photo?

In a good picture, you can tell right away what the starring subject is!

▶ Consider these questions to find new pieces of evidence.

1. What is the starring subject in each of these pictures?

2. Did you spot the trick photo? One of these pictures is a failure because it does not have a prominent starring subject. Which picture is it?

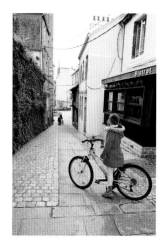

A

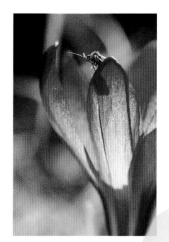

B

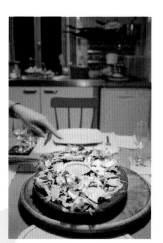

C

D

E

1. The subjects are: A: the girl in the red coat; B: the insect; C: the salad; D: ummmm ...?; and E: the dandelion flowers.

2. The picture that doesn't belong is D, because you can't really tell what the subject of the picture is supposed to be. None of the people in the picture are visible enough to make a good starring subject, and on top of that, the people in the picture are all crowded together.

 ## Now you frame it. Tropical fish

What are we waiting for? Let's put our super strategy to the test! Are you ready to make one of the fish in the aquarium on the next page into a star?

▶ When you're ready, take out your cardstock frame (see page 9) and get started!

1. Choose the fish that is going to be your starring subject.

2. Place your frame over the picture of the aquarium so that the fish you chose is inside the frame. Simple, right?

3. Now, if you want to, do it again with another fish.

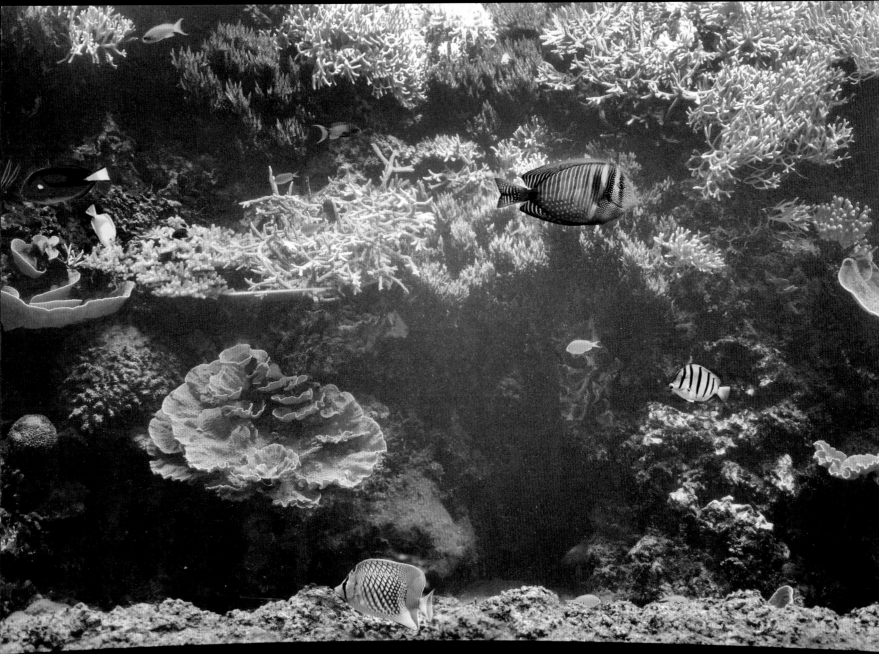

Deductions. The king of the aquarium

Here are the photos that I took of some of the fish from our aquarium. The pictures that you took were probably a little bit different from mine, and that's how it should be!

▶ Try to lay your frame on the previous page in such as a way as to take the same pictures that I did.

Wouldn't it be cool to "photograph" the yellow and white fish with the black stripes over on the right side of the aquarium too? And what about the pretty blue, black, and yellow fish all the way over on the left? Had you thought of that?

▶ Now get out your frame again and play around with it!

Strategy. Framing

The frame is just the outline, or borders, of the picture. And choosing where to put your frame when you are looking at the subject is called "framing a picture"—it's that simple!

The position of the frame—whether it is a cardboard frame or the frame created by your camera—relative to the subject is called "framing." If you put your frame around a fish in a different way than I did, then we can say that you framed it differently.

Framing is a powerful tool because it allows you to change the picture until it is exactly the way you want it!

All through this chapter we will be exploring how to do that.

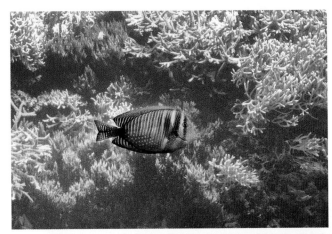

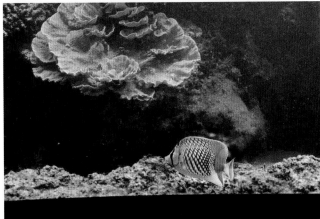

Picture quest. There's the star!

▶ Now it's time for the picture quest with your camera!

Here is your assignment for today: Before you take a picture, say out loud what the subject is that you have decided to photograph. Doing this will help you know for sure what your starring subject is, which will help you take cool pictures. Don't forget: a cluttered photo is your worst enemy!

Pesky intruders!

Let's investigate.

Found an ugly thingamajig!

Here we'll find a new **piece of evidence**. It will definitely help us collect some more clues!

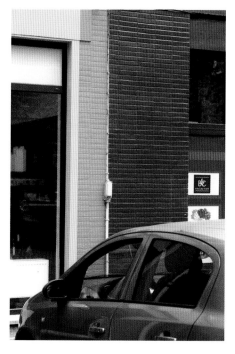

When I took this picture, I knew exactly what my starring subject was: this yellow and purple wall, which I think is really cool.

▶ So, what do you think of my picture? Give me your honest opinion!

The colors on the wall are nice, but that car there is ugly, isn't it?

Strategy. A plan to get rid of the things that sneak into pictures

It's really great to have a **super starring subject**, but what a waste if there's such a **horrible thingamajig** in the picture with it!

Getting rid of things that sneak into pictures is going to be a very important stage of our operation. Here is what our **strategy** is going to look like.

Before you take a picture, **examine it** very carefully to find the **sneaky intruders**. Is there anything in the frame that is **ugly** and that **you don't want to have** in there? Don't let it ruin your picture!

Mercilessly eliminate all the **sneaky intruders** that are trying to **creep** their way into your picture.

You didn't pay to get in, you lousy pests! I will chase down every last one of you! Ha ha ha!

19

Aaaah, isn't my picture of the two-toned wall better this way? Nice and simple, without anything there to ruin my colors!

This new strategy is fantastic, isn't it?

The fight has only just begun, and fortunately, we have a whole book in front of us to help us discover how to flatten our enemies! Our vengeance will be terrible!

Considering the evidence.

Hunting down undesirables

Here is a picture of a young woman having a snack.

▶ Can you find the pesky intruder that has snuck into the frame? Find at least one ugly sneak in this picture!

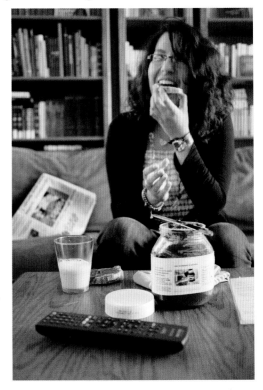

The worst offender here is the remote control. The picture also would have been better if I had gotten rid of the newspaper, the lid of the jar, and the piece of paper all the way over on the right by taking a tighter closeup shot. Right now the bottom of the photo is kind of a hodge-podge of things.

 Let's investigate. Gorgeous garbage cans?!

There is still another mystery left to clear up: What kinds of things are intruders in our photos? Are cars, remote controls, power lines, and garbage cans always a problem?

[Answer key, printed upside-down:]

1 and 2. Photo A: These nice clean green garbage cans are pleasant next to the blue door. Photo B: The gray garbage can is not very nice to look at; it's an ugly impostor. Photo C: Overflowing gray garbage can: ugly intruder! Photo D: This red garbage can in front of the colorful house is pretty. Good subject! 3. Colorful garbage cans are often better looking than gray garbage cans. And if they're clean, that's perfect!

▶ Study the following pictures.

1. Find the garbage can or cans in each picture.

2. For each photograph, decide whether the garbage can is an unpleasant intruder or a charming subject for the picture.

3. What do you think makes it possible for a garbage can to be a good subject?

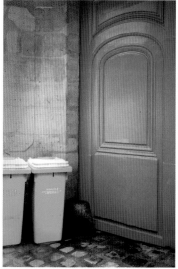

A

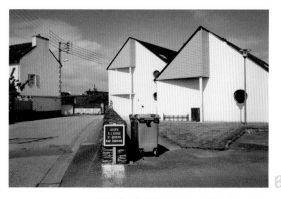

B

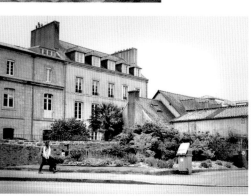

C

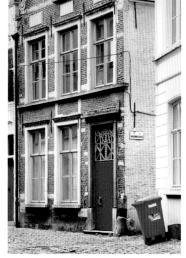

D

Deductions. What makes an element of a picture an intruder?

Sometimes an object can be pretty, and other times that same thing is not pretty at all! So posts and electric wires, garbage cans, cars, road signs, wilted flowers, manhole covers... sometimes these are ugly things we want to keep out of our pictures. But sometimes they can be interesting to photograph!

It is up to YOU to decide whether something is in the way or is a good subject. Just make sure that the picture looks good, whatever you decide to keep in the frame!

Picture quest.
Getting rid of the intruders

▶ Quick, go get your camera! Here is your assignment.

1. Every time you get ready to push the button to take your picture, look carefully one last time at everything that is in the frame. Are you sure there is no ugly intruder left that might spoil everything?

2. Get rid of the troubling elements if you can. But if you don't know how to do it, don't worry, because we are now going to arm ourselves with some super-powerful secret weapons that will help us to conquer ugly things!

The riddle of the tractor

It's all well and good to want to get rid of the ugly things that sneak in, but those pesky intruders are tough!!!

That's for sure! If only we could discover a super-effective secret weapon for getting rid of those things, that would be really helpful.

Now you frame it. Even more garbage cans!

Let's investigate, starting with this tractor scene. The sky is blue, the grass is green, the tractor is red, but the garbage cans are gray, so let's figure out how to get rid of them!

▶ Place your cardstock frame on the next page so that it lines up with the black outline. What you get is the picture we see below: nice, but... jeepers, those garbage cans! How can we get rid of them?!

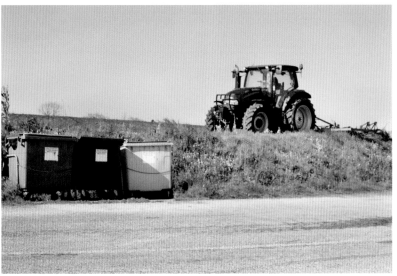

1. What do you have to do so that the ugly intruders—the garbage cans—are not in the picture anymore?

2. Position the cardstock frame on the book so that the picture you see matches what you are imagining. Can you position the frame so that you can see the tractor in the field, but not the garbage cans?

3. Now try to find another way of framing the picture that also allows you to see the tractor without the garbage cans. What is the difference between the two ways in which you framed the picture?

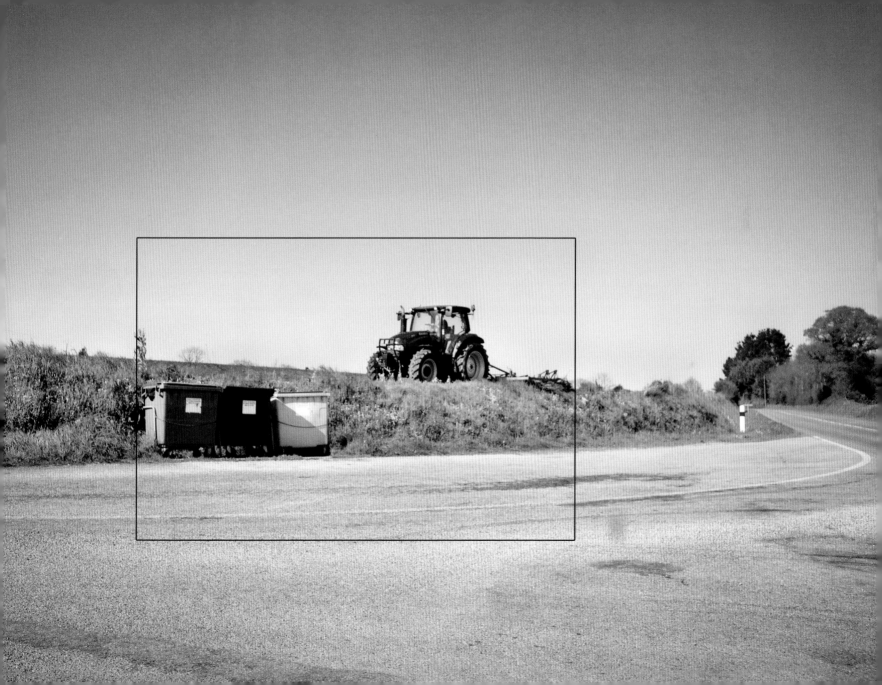

Deductions. Moving the frame

In order to get rid of the intruders, you have to move the frame by sliding it across the book!

Here's what happens when I move the frame to the right in order to get rid of the garbage cans.

First, the ugly intruder is cut in half by the frame: it is half in and half out of the photo (2nd picture). And then, if I move the frame a little farther, our lousy intruder is not in the photo at all anymore (3rd picture)!

▶ Place your frame on the black outline one more time, then move it to the right until you can see red-and-white post. Now you've framed it the same way that I did.

There, I move the camera to the side! The blue arrow that you see next to the picture of the camera shows you what to do.

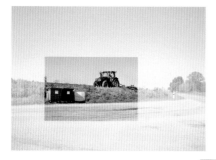 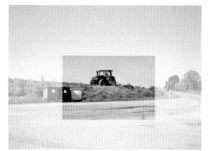 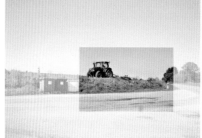

And here's what we have! A lovely, colorful picture without any ugly elements! The post, with its little bit of red like the tractor, is perfect for the picture!

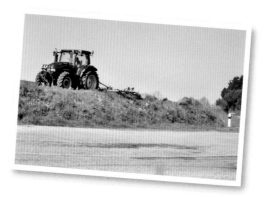

Oh, but I have another idea! What if I moved the frame upward? Then the garbage cans would disappear below the picture.

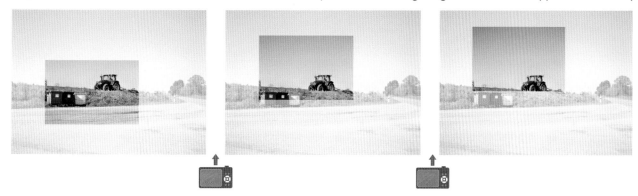

Oh shoot, that doesn't work very well. It looks like the tractor is about to leave the picture too.
But on the other hand, there is nothing stopping me from moving the frame to the right AND up!

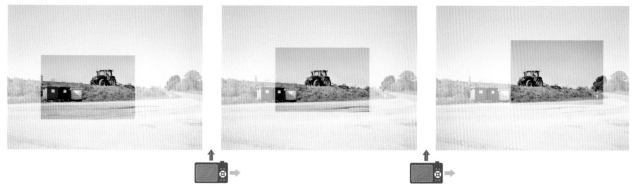

This way, I get rid of those crummy garbage cans and I also frame my picture in a new way, with hardly any of the road and more of the beautiful blue sky. Not bad, huh?

▶ Can you do this double-shift of the frame on the picture on page 23 so that you get this neat framing effect? Use the road and the post as guides.

Shifting the frame

The secret weapon. Moving the frame

I think that you have just discovered photography's first secret weapon: shifting the frame!

Move your camera to the left, to the right, up, or down, and you will change what's in your picture!

An inch or two, or even just a few fractions of an inch, can make a huge difference. Talk about a precision weapon!

Use the upper part of your body to shift the camera: your chest, your arms, your hands! The investigations that follow will help you learn to use your weapon even better.

> I bet you've already started using this weapon without even realizing it, haven't you? Ha ha!

Let's investigate. Up or down?

When there is something that has snuck into the picture that is at the top or bottom of the picture, all you have to do is raise or lower the camera a little to get rid of the intruder!

▶ In my first picture of a bell tower against a blue sky, the cars really spoil the landscape!

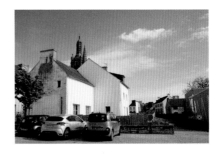 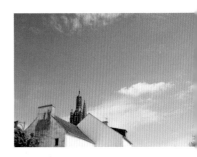

1. Where are the intruders in this picture?
2. How did I move my camera in order to keep them out of the frame?

1. The cars are at the bottom of the picture.
2. I got rid of them by moving my camera toward the sky; in other words, upward.

Further investigation.
To the right or to the left?

When I took these pictures, I wasn't paying attention, and they all contain some element that has snuck into the picture somewhere!

▶ Study these pieces of evidence.

When the problem element is on the left-hand side of the picture, I need to move the frame to the right, and vice versa. That's strange, isn't it?

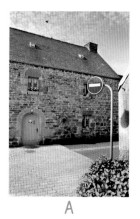
A

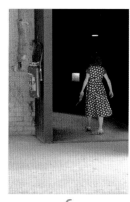
B

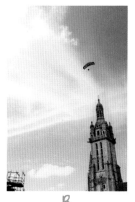
C

D

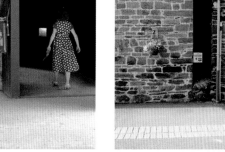
E

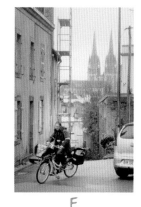

1. Find the things that snuck in: a Do not enter sign, a piece of scaffolding, a fire extinguisher, a rusty gutter pipe, and part of a car.

2. Which direction do you have to move the camera to get rid of each of these sneaky intruders? To the left or to the right? Connect each of the pictures to the drawing that shows the camera moving in the direction it would need to in order to get rid of the trespasser.

 ?

To get rid of the problem elements in photos A, D, and E, move the camera to the left; for photos B and C, move the camera to the right.

Strategy. Multiple shifts

What if the sneaky element is in the corner of the picture?

Well, if that happens, you'll have to move your frame in two directions at once—for instance, up and to the right, the way we did for that last picture of the tractor!

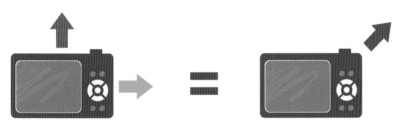

So, to review: Our first secret weapon is moving the camera in any direction we want to in order to shift the frame.

This weapon is very easy to use but also very powerful. Even more powerful than you could have dreamed, you'll see!

As a matter of fact, you don't even have to think about it too much. All you have to do is move the frame around in every direction until that sneaky element is gone!

Picture quest.
Our camera can't stop moving!

▶ Let's organize a special picture quest with a "camera on the move" in order to perfect our strategy and learn how to use our super weapon!

1. Frame a subject of your choice and then follow this coded message (move your camera in the direction shown by the arrows).

Did the framing that you found make you want to take an actual picture? If you want to, you can move your camera a little more to frame your picture better, and then take the picture!

2. Let your camera dance freely around in space and when the frame looks like it has captured something good, take the picture!

 ## Now you frame it! On the desk

Train yourself in the art of framing with the overhead view of my desk on the opposite page.

▶ Here are some different instructions for framing. Every time, certain elements of the picture are considered to be intruders, and it is up to you to keep them entirely out of the frame!

1. With your cardstock camera, "take a picture" of the red polka-dot notebook. Watch out, the eraser is an intruder!

2. Frame the pencil case but don't let the white-out pen get into the picture!

3. Take a picture that shows the paper clips but not the lollipops or highlighter pens.

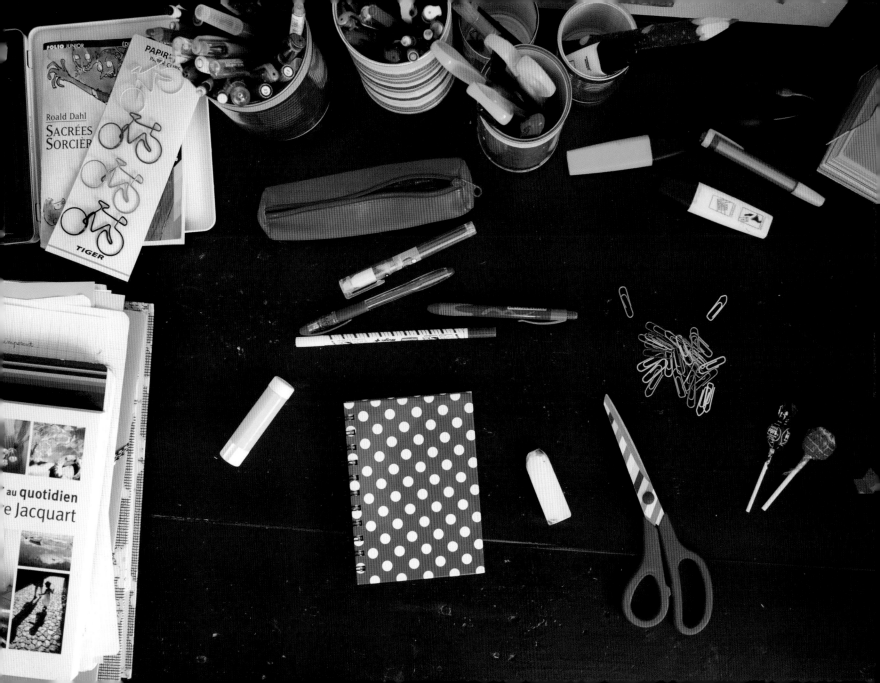

There is more than one way you could have framed each of these pictures while keeping the intruder out. Here are my framing suggestions.

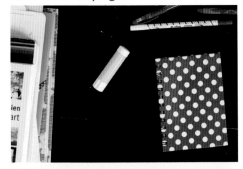

1. Here is the notebook without the eraser.

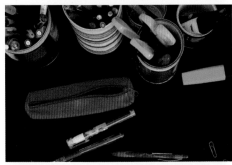

2. Here is the pencil case without the white-out pen.

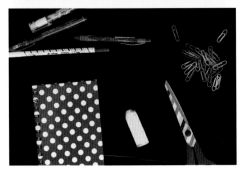

3. Here are the paper clips without the lollipops or highlighter pens.

Feel free to go back and position your cardstock frame over the view of the desk again, using my framing suggestions if you would like to.

Deductions. Removing something on one side and adding something on the other?

Did you notice this when you tried framing the pictures? When you move the frame to cut an intrusive element out of the picture, new things come into the picture on the other side of the frame!

So we have to ask ourselves whether those elements are useful for our picture or are new intruders that we have to get rid of as well!

Considering the evidence.
Impossible framing

On top of everything else, we can't always do things exactly the way we want to. There are "impossible" framing setups that just cannot be achieved! That is why it is so hard to solve the riddle of photography.

▶ Of the pictures described below, find the ones that cannot be taken. Use your cardstock frame and the desk on page 29 to try to frame each of these pictures to make absolutely sure!

A. A picture of the pencil case with the bicycle-shaped paper clips.

B. A picture of the scissors without the eraser or the lollipops.

C. A picture of the red polka-dot notebook and the scissors.

D. A picture of the bicycle-shaped paper clips without the pink-and-orange pen.

E. A picture of the glue stick and the lollipops.

B and E are impossible to frame. You can't get a picture of the scissors without the eraser and the lollipops because they are too close to each other. And you can't get the glue stick and the lollipops into the same frame because they are too far away from each other.

Same weapon, different effects!

Let's investigate.

One cow, two cows...

The other day I took a picture of a cow. The picture that I took (on the left) was nice but not super interesting. So I used the frame-shifting weapon to take another picture with a little more going on!

This time, the issue was not getting rid of an intruding element.

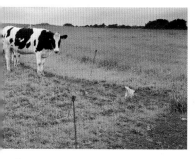

▶ Let's look at this a little closer!

1. How did I move my camera to get from the first frame to the second one?

2. How did this framing change help me?

picture.
2. Changing the frame allowed me to add another cow to the
1. The camera was moved to the left.

Strategy. Paring down or adding more?

So it looks like our secret weapon has more than one trick up its sleeve! It is very useful for making those pesky intruders disappear from our photos, and it is also good for adding a subject to the picture.

Move the frame toward a subject you like to bring it into your picture!

 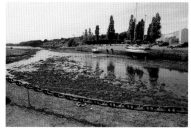

Here I tilted my camera downward so that I could add this rusty chain and the strip of orange-colored earth to my picture. Now my photo is even richer and more colorful!

Picture quest. In addition to the starring subject

▶ Here is your new assignment.

1. Find a subject that interests you and frame it.

2. Now notice the things that are next to your subject but are outside of the frame. Which of them would you like to add to your picture?

3. Move your camera toward the new element to add it to the frame. Are you able to do that without losing your starring subject? It's not always easy, remember, because some frames are impossible! But don't worry, we will soon find another secret weapon that will make EVERY frame possible!

Hey hey! So are you a pro at framing too?!

So how is your secret mission going? Do you feel yourself becoming a true photography adventurer, page by page?

We are still only at the very beginning of this quest, and yet, I see that you have already collected a number of pieces of evidence, developed some very intelligent strategies, and even found a secret weapon. Wow! What a fantastic start! Congratulations.

As you have been able to see for yourself, shifting the camera is a very powerful weapon. With that weapon, framing becomes child's play! Are you ready for new challenges? I am counting on you to keep cutting through to the heart of the mystery of framing and photography, wisely and with enthusiasm!

You have to admit, it's fascinating to watch the picture evolve with the slightest shift in framing.

A new weapon for framing

The secret of the white feather

Now you frame it. I'm getting dizzy...

Let's keep investigating framing.

Our next topic of investigation: this lovely feather, waving in the ocean breeze!

The ocean has created sand waves, which are turned into lines written on the beach by the angle of the sun.

▶ Your assignment is to find out how to frame these pieces of evidence using your cardstock frame.

Look at these pictures, one at a time, and then...you frame it!

Use the position of the butterfly shell and the sand swirl to help you frame these just right!

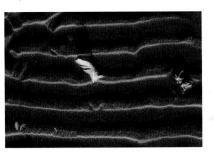

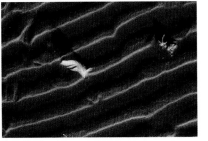

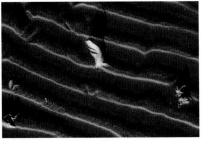

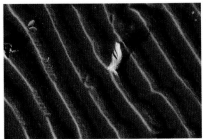

A B C D

Hint: What direction are the sand waves going in each picture? How do you think you need to move the frame

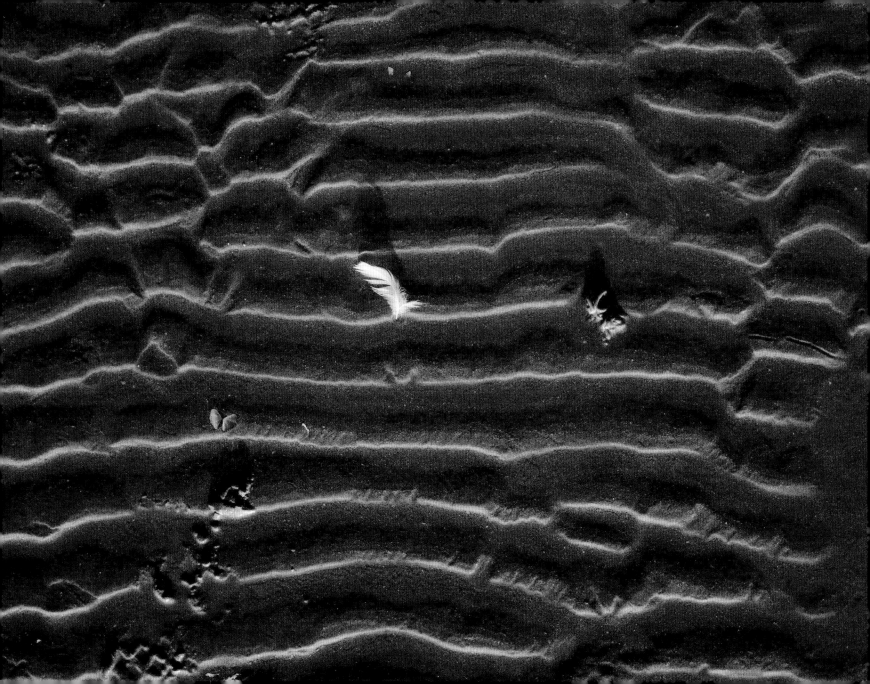

Deductions. Tilt the frame!

Have you figured out which new movement of the frame is the key to the mystery? That's right, to make certain photos you had to tilt the frame sideways! You can also say "incline the frame."

To make photo A, it was easy. All you had to do was set up the frame, nice and straight, and then place the feather approximately in the middle. The butterfly shell is in the bottom left corner and the sand swirl is near the right-hand edge.

A

In photo B, the sand waves are tilted. Did you guess that meant that what you had to do was tilt the cardstock frame? Here you tilt the frame to the right so that the waves of sand look like they are going up in the picture. The butterfly shell is not in the picture anymore and the sand swirl is now almost in the top right corner.

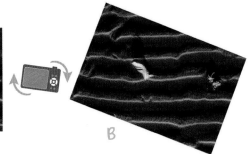

A

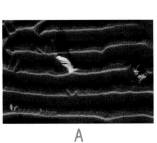

B

In pictures C and D, the lines are tilted in the other direction. So this time you have to tilt the frame to the left! When I do that in order to get photo C, the shell moves up along the left-hand edge and the swirl moves down along the right-hand edge; isn't that cool?

You have to tilt the frame even more to make photo D, with the butterfly shell right in the corner. As for the sand swirl, it isn't even in the picture any more!

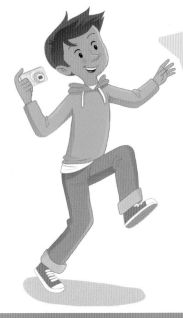

> Oh, but of course! That makes total sense! Tilting the camera, why didn't I think of that sooner?! Coooool, a new secret weapon!

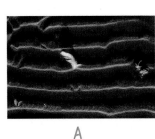

A

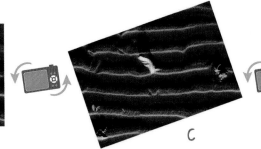

C

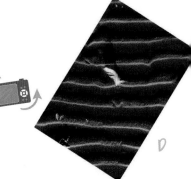

D

Secret weapon.
Tilting the frame

I now have the pleasure of solemnly handing over to you the second secret weapon of photography: tilting the frame!

Tilting the camera to the side (to the right or to the left) allows you to change your framing as well!

When I tilt the frame to the right, the lines tilt to the left in the picture! Very strange!

When I took this closeup picture of a plate of fruit, I didn't like the picture that I took with the camera level.

Then I thought of trying to tilt it, just to see. And sure enough, the framing looked much, much better!

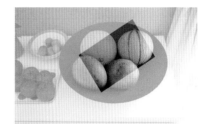

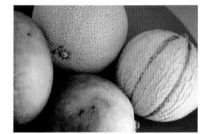

Considering the evidence.
The ground is covered with clues!

▶ What about you? What do you have under your feet? Wood flooring? Tiles? Linoleum? A rug or a carpet? Even better: is the sun making lines on it?

1. Direct your camera downward to take a picture of the ground.

2. If necessary, tilt your camera to the side in order to:

 - frame your picture to follow the lines on the ground (as in photo A on page 36: the lines should follow the edges of the frame);

 - frame your picture so that the lines run diagonally.

It can be fun if your feet are showing in the picture!

Deductions. Tilting the camera?

Maybe you thought that a tilted photo was always a failure, and that you're not allowed to tilt the camera sideways? But in fact, that can't be true, because tilting it is actually a secret weapon!

Picture quest.
The prancing frame

Let's play with tilting pictures!

▶ Take pictures of different subjects with the frame tilted to the side!

Take closeups of fruit or different objects as well as broader views of your room, the kitchen, or the yard. Is it fun playing with tilting the camera?

▶ Another challenge! Frame your picture the way you want to and then follow this coded message.

Do you like the framing that you ended up with? Adjust it and make it better, if you like, before you finally take your picture.

Tilting photos

Let's investigate.

Will it tilt? Or won't it?

Still, some photos that are tilted are a little odd, don't you think? Let's look for some more clues about tilted frames so that we can understand this better.

▶ Look at the tilted photos that you took in our last picture quest (see page 37) on the screen of your camera or on a computer. Do they all look tilted, or do some of them seem "normal?"

Does it look strange that some of the pictures are tilted?

Which ones do you think would have looked better if you had held the camera straight?

> Ugh! Some of those pictures make me feel a little seasick!!!

I had fun playing around with tilting my frame too. EVERY SINGLE ONE of the pieces of evidence below was taken with the camera tilted!

▶ Which of these two pictures looks funny? Do you think you know why?

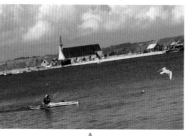
A

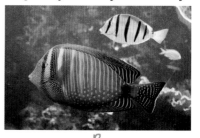
B

And what do you think of these tilted flowers? Does one of the photos look strange to you? What things should not be tilted?

C

D

Of these two tilted pictures of the sky, which one should I have framed straight-on, without tilting my camera? Why do you think that is?

E

F

The pictures that make you feel seasick and look strange are pictures A, C, and F. On the right-hand page, we'll talk about why that is. Pictures B, D, and E are fine: I tilted my camera to take them, but even so, they don't make you feel seasick!

Deductions. Seasickness

So here are the clues we have collected.

Tilting the frame to the side is not a good idea when you are taking a picture of:

- a landscape, a building, or a boat (photo A on the previous page);
- a window or a vase (C);
- the city, its street lights, its posts, or its houses (F).

On the other hand, we can say that tilting the frame is not a problem when you are taking a picture of:

- an animal, if you don't show the ground (B);
- a closeup of a flower in nature or a garden (D);
- a view of the sky without any buildings (E).

Strategy. Solving the mystery of the tilted picture

When you take pictures of things that are always level (a table, a window, the ground, a vase, a house, a sign), it's better not to tilt the frame to the side!

On the other hand, when you take pictures of things that are not necessarily always straight (a flower or a branch would often be naturally tilted), then tilt your frame if you want to, especially if you are taking a closeup.

▶ Think about the subjects in the following list and decide which ones you could photograph with your frame tilted a little bit without it looking strange:

- a person standing up
- a poppy
- your house
- part of a car
- a bird in the sky
- electric poles
- a country landscape
- a funny spot on the wall

You can frame the following things with your camera tilted: a poppy, part of a car, a bird in the sky, and a spot on the wall. But it would be better to hold your camera straight when photographing the other subjects.

When the subjects make you feel like they are going to fall over in the picture, it's better to straighten the frame. To make sure my picture is going to look all right, I tilt my head in the same direction I tilt the camera; that helps me to see what the picture will look like when it's laid flat.

Picture quest. Straight or tilted?

▶ Now go take a few pictures, either tilted or straight. It's up to you to decide how to do it!

Hold your camera straight for subjects that can't be tilted, and for the rest, have fun tilting your camera to the right and to the left until you find the best frame!

Horizontal or vertical

Strategy. Framing horizontally or vertically

If we tilt and tilt and tilt the camera, it can sometimes end up completely turned on its own axis. And that's how we get our secret weapon no. 2, which lets us turn the camera all the way on its end. This is vertical framing.

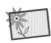

To frame vertically, you generally turn the camera by lifting your right hand, the one that pushes the button to take a photo.

Let's investigate. Lying down or standing up?

Because the camera frame has an elongated shape, while keeping it straight we can:

- hold it in a horizontal position so its lying down;
- stand it up in a vertical position.

Let's investigate using the pictures you have already taken.

▶ Look at some of your pictures on the camera or on a computer. Did you take any vertical pictures?

Do you take more horizontal pictures or more vertical ones?

▶ In the "Now you frame it" section on page 23, there was another way to frame the picture that would show the tractor without the garbage cans—vertically, of course! With your cardstock frame, take another picture of the tractor without the intruders using your secret weapon no. 2.

Be patient, and on the next page I'll show you how I framed it. Then you'll see if we had the same idea!

Now you frame it. Under the parasol

▶ We are going to take two pictures of this beach scene. Each way of framing it will tell a different story.

1. First show the couple with the parasol and the lighthouse. Which way are you going to position your frame, horizontally or vertically? Why?

2. Now show the couple with the parasol along with the children who are playing at the edge of the beach. How are you going to frame the picture this time?

Deductions. Pictures that tell a story

Here's how you probably positioned your frame to solve each riddle.

The lighthouse is sort of above the couple with the parasol, so you have to use a vertical frame to get both of them together in one picture. When you look at this picture, don't you get the feeling that the couple is all alone on the beach?

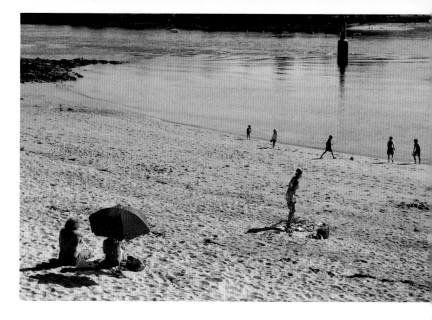

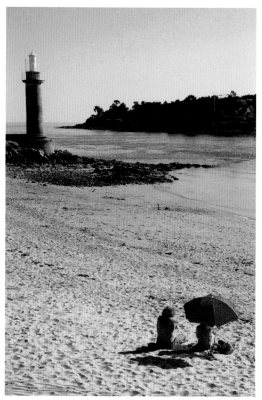

The children playing are more or less next to the couple with the parasol, so a horizontal frame works best this time! Here you can see very well that there are a lot of people on the beach. You might wonder whether the children of the couple with the parasol are out there swimming.

And as for our good old tractor, here is a new framing solution that could also have helped us solve that riddle. The vertical format allows us to show more of the sky or the road (but a little less of the grass). My choice was to keep plenty of blue sky!

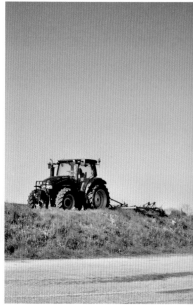

Considering the evidence.

Coded framing solutions

So that we can be sure our strategies remain secret for now, I will sometimes allude to the framing of various photos with drawings that are a little bit like secret codes.

For each of our new pieces of evidence, I am also including an encrypted document showing how I framed the subject or subjects.

▶ What do the encrypted documents show?

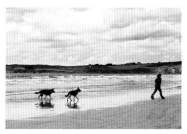

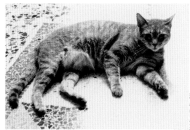

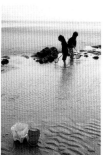

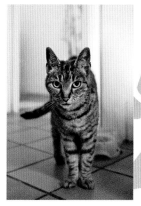

Hint: There are only two wrong answers here!

▶ Which of the following sentences are good clues for framing? If you need to, look at the hint hidden on the page!

A. Vertical framing is great for taking pictures in which one subject is on top of the other.

B. Vertical framing is the best way to frame cats.

C. When an elongated subject is lying down, like a pencil case or a banana, framing it horizontally is the best way to take a picture of the whole thing.

D. When an elongated subject is standing up, like a glass of orange juice or a door, it is better to use a vertical format!

E. Horizontal framing is cooler than vertical framing.

F. Smart photographers first look at the shape of the subject or the layout of the objects before choosing the direction of the photo.

The encrypted documents show the shape or layout of the subjects within the picture.

The clues are sentences A, C, D, and F.

Strategy. Fitting the direction of the frame to the subjects

All you need to do is look at the subject, or the important elements in the scene that you want to photograph, to decide on the best way to frame it. But sometimes you're not sure.

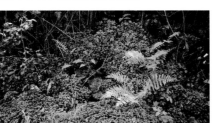

When I first saw this fern against the lovely background of greenery, for example, I wanted to frame it horizontally because the green zone had a sort of lying-down shape.

But then I tried out a vertical frame and I realized that there was a little pool of water below the green spot that was reflecting the blue sky! If I took the picture vertically, I could show the fern and the pool in the same picture. Even though I like both the pictures, I think that the vertical view has prettier colors, with the blue next to the green. What about you? Which do you like better?

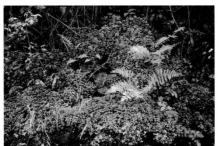

Let's investigate. What do you see?

▶ Well, well, well, these two pictures of a sunset landscape are interesting!

1. What can you say about these pictures?
2. Do you know what this kind of picture is called?

1. These pictures are not in the same format as the others. The first one is horizontal but very stretched out. The second one is neither horizontal nor vertical.
2. The first picture is called a panoramic photo. The second one is a square photo. So there are other formats besides "normal" horizontal and vertical photos, even if you don't see those other formats quite as often!

Oh, I know all about that shape; my big sister posts square pictures on Instagram all the time!

Picture quest. Now you choose!

▶ Choose between the horizontal and vertical format for taking a picture of your subject or subjects. If you're not sure which one you want to use, take two pictures!

▶ Does your camera let you change the format? Does it take panoramic or square pictures? Practice framing your pictures in different formats!

What shocking equipment!

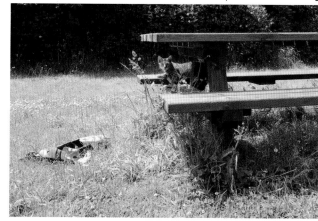

Considering the evidence.

Taking stock of our weapons

Are you keeping track of what equipment you have at this point? I suggest that you quickly take stock of your formidable weapons before continuing your investigation. And once again, there is a cat in the picture too!

Oh boy, how did I not see that piece of cardboard on the ground right away?! Fortunately, I made up for it in my other pictures: each time, I got rid of the undesirable party-pooper by using a different method. It was a lot of fun!

▶ Compare photos A, B, and C with my first picture, which includes the intruder.

1. Which secret photographic weapon allowed me to defeat the intruder in each picture?

2. One of the pictures is a little crazy. Which one?

I think we are now ready to take on the next chapter!

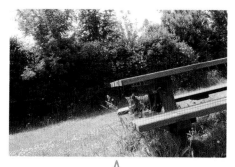

A

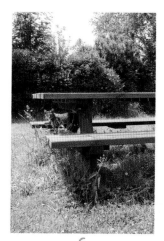

C

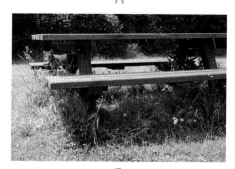

B

It's another picture that makes me feel seasick!
2. Picture A is a little crazy because the horizon and the picnic table are tilted sideways.
weapon no. 2 again).
finally, by tilting my camera so far that framed the picture vertically (picture C: secret
no. 2); then by moving the camera to the right (picture B: secret weapon no. 1); and
1. I first got rid of the piece of cardboard by tilting my frame (picture A: secret weapon

Isn't it great to be able to change the frame just by moving the camera?

Our first two secret weapons help us do so many things! With them we are able to choose a starring subject, get rid of intruders, add new elements into the picture, tilt the contents of the picture, and frame the picture vertically or horizontally.

You might not know what hit you when you discover the last secret weapon, which is also overflowing with amazing photographic superpowers!

So, you guessed it: your toolkit is not quite complete! But soon you will have such powerful weaponry that our strategies of framing and composition will seem as easy as pie to you!

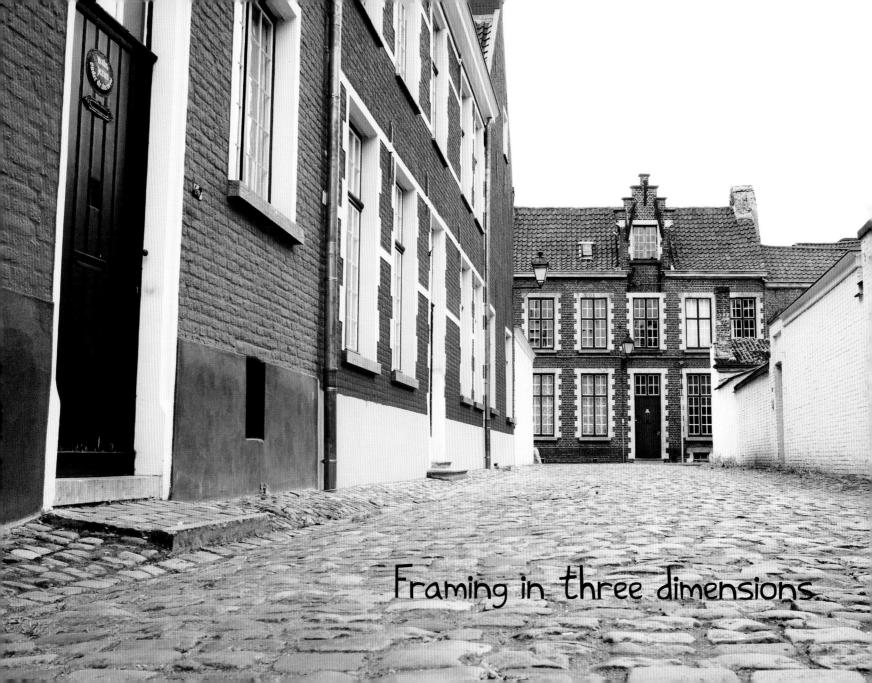

Framing in three dimensions

The third secret weapon

Let's investigate. A new way to get rid of that pesky cardboard

Let's go find our cat one last time.

Oh wow! Talk about pieces of evidence! What do you think about this?

 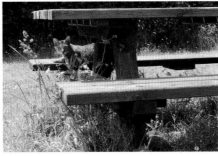

First of all, here is my ugly picture with the piece of cardboard.

And now it looks like this is a new version of my picture without the crummy intruder!

▶ Can you guess what action I took before snapping the second picture?

Oh gee! Here it comes, the new secret weapon!

To take this picture, it looks like I got closer to the subject. Or maybe I zoomed in with my camera? I can't remember for sure anymore.

▶ To get rid of the intruder, what do I mostly move this time?

A. My camera?

B. My body?

C. The subject?

Answer B! This time, I move my whole body! On the other hand, if I zoom in with my camera to take the picture, then nothing moves.

Picture quest. Move!

▶ Don't you want to stretch your legs a little? That's good, because now I am going to ask you to MOVE! And watch out, this is not about moving the camera just a smidgen this way or a touch the other—this is about taking large strides!

1. Look for a subject that you like and take a picture of it.

2. Move closer to it, taking large steps, and then take another picture.

3. Try to notice what changes when you get closer to the subject.

Now you are better equipped than ever!

 Let's investigate. Gorgeous colors

Let's study how this weapon works more closely.

I took these pictures in a village a few days ago. Unfortunately, in my first picture, you can't see the flowers very well and there are pesky intruders spoiling the landscape.

▶ So I took a few steps forward and I took another picture.

1. Which elements disappeared from the picture? List as many of them as you can!

2. In the first picture, where are the elements that you listed? Point to each of them with your finger.

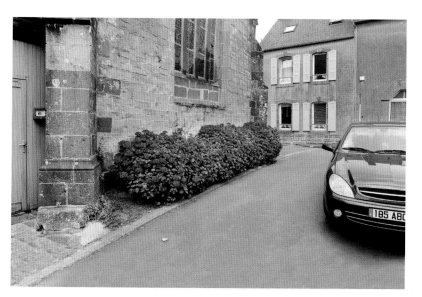

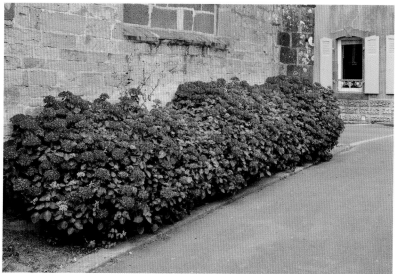

1. The elements that have disappeared are the car, the green door with the little red box, the stone pillar, some of the windows, the roof of the house, part of the road, and the piece of paper that was lying on the ground.
2. The things that have disappeared are all around the edges of the first picture: on the left and right, at the top, and at the bottom.

49

Deductions. Good-bye to the mess all around!

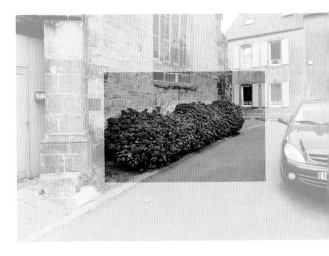

So getting closer to the subject (or zooming in, if your camera will do that) is not just useful for getting rid of an element that is on one side of the picture, but it can help you get rid of intrusive or unimportant things on all sides. Pretty good, right?!

When I move forward, I eliminate everything that is in the grayed-out band all around the edges of the picture. This way, I can keep just what is in the center of the picture: what I think is the nicest to look at.

Further investigation. In the kitchen

Now we know what happens to the elements that are all around the outer edges of the picture (hehehe, adios amigos!). And what about the subject, then? Here are some new pieces of evidence.

My subject is the pile of colorful bowls in the middle of the frame.

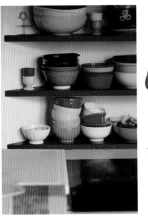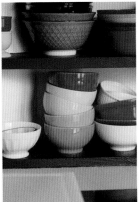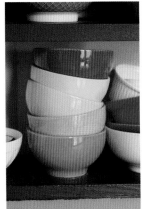

You know what, I think I actually already knew all that, but I just didn't quite realize it.

▶ So what happens to the subject as I get closer and closer to it?

The subject becomes larger and larger in the picture the closer I get to it!

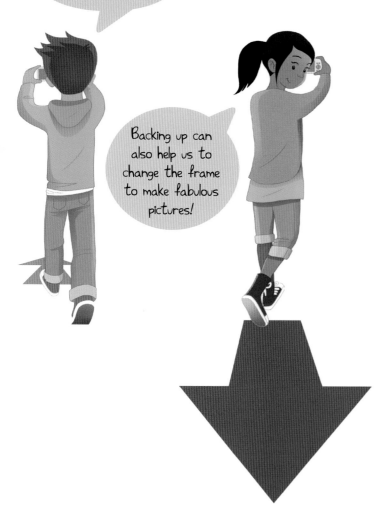

 TOP SECRET **The secret weapon.**

Your legs are a secret weapon!

Moving your whole body allows you to change your frame and can also make your subject look larger!

So you can get closer (see the orange arrow), but that's not all—backing up (see the purple arrow) can also help you make your picture better!

But be careful and remember to look where you're walking when you back up!

Get closer to your subject (or zoom in with your camera):

– to make your subject larger in the picture; or

– to get rid of intruders that are all around the outer edges of the photo.

Move away from your subject (or zoom out with your camera):

– to make your subject smaller in the picture; or

– to bring new subjects into the picture from all sides.

So this is all strategic! Moving forward or backing up is very useful for choosing:

– the size of your subject in the picture; and

– whether or not you want to show what is all around it.

Considering the evidence. Whoops!

▶ There is a mistake below. One of the "go forward" or "back up" arrows is wrong. Can you find the one that's wrong?

A1 A2

 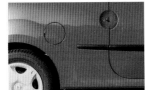
B1 B2

C1

C2

The arrow between photos C1 and C2 is wrong. The photographer moved forward, not back, before taking the second picture.

▶ Here are ideas for pictures I want to take. Do I need to move forward or back up to:

A. take a picture of a dog in the city without showing all the stuff around it?

B. make a sunflower look smaller in the picture?

C. take a picture of almost my whole back yard?

D. take a closeup of my friend's eyes?

The answers are: A. move forward; B. back up; C. back up; and D. move forward.

Are we going to have another one of those "Now you frame it" activities soon? I love trying out the different framing possibilities!

No, you can change how you frame a picture with the cardstock frame, but you can't back up or move forward with your feet! That is something you have to do in the real world. Get your camera ready!

 ## Picture quest. Abracadabra!

Here is your new assignment. Are you ready to experiment with the magic of secret weapon no. 3? All right, go on out and enlarge and shrink your subjects all you want!

▶ Choose your starring subject and then say, "Abracadabra, make yourself bigger!" while you walk forward three steps. Take the picture!

▶ Now choose a new subject and say the magic words, "Abracadabra, shrink yourself!" while carefully taking seven steps backward. Take a picture of your mini subject!

Another dimension

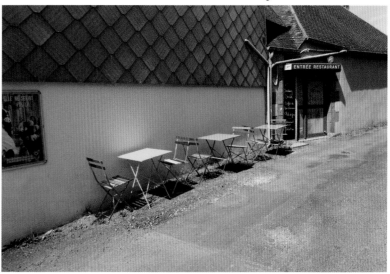

 ## Let's investigate. Perspectives

Something tells me that our new secret weapon is playing its cards close to its chest. Are you sure you're using it to its full potential?

These two original, unretouched pieces of evidence will bring you some new clues that will widen your horizons some more!

▶ Look carefully at these pictures of pretty, colorful tables and chairs. Did I just take a few steps forward in order to get rid of the sign and the entrance to the restaurant? What movement or movements did I make?

I moved toward the tables and chairs, but more importantly, I also moved to the right and faced my subject.

▶ Find the clues that these two photos allowed us to collect.

A. Moving in space only allows you to change the size of the subjects in the picture.

B. Moving in space allows you to see the subject from a new angle.

C. After taking the first picture, I moved one step forward and then I took the second picture.

D. You can move around in ways other than just forward and back.

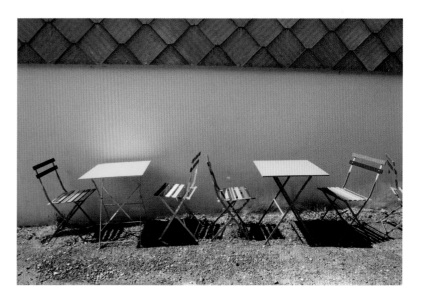

Sentences B and D are our new pieces of information.

 The secret weapon. The second dimension

But of course! This weapon of moving around in space not only lets you move forward and back, but it also lets you move to the right or to the left!

> With weapon no. 1, in order to move the frame to the right, all we moved was the camera...

> ...but this time, with weapon no. 3, when we move to the right, it's our whole body that moves! You have to make your feet move!

So that makes a total of four different directions in which you can walk in order to change where you are and get a new perspective on the subject!

 + **=**

If you think about it, there are actually even more than four paths to follow. Right here, I have drawn eight arrows, but you could draw even more arrows between the arrows because there is an infinite number of possible movements in space. Hurray!

> You can move sideways, like this, like a crab.

> Or you can turn your whole body to face the imaginary arrow, but without losing sight of your subject!

 Picture quest. The twelve steps

▶ Is the photographer still ready?! Here is the assignment for the day!

1. Go outside and find a subject to take a picture of. You can also do this picture quest on a walk. It's better if there is lots of room around you.

2. Take a picture of your subject.

3. Now take twelve large steps in different directions while continuing to look at your subject. For example, walk to the side a little bit, then move forward or backward, walk around your subject, and stop when you get to twelve!

4. Take another picture of your subject. This picture will probably be very different from the first one.

5. Now start over again with another subject if you'd like!

An ant or a giraffe?

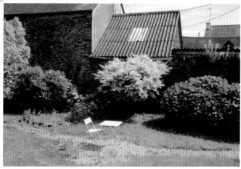

Let's investigate.
The third dimension of our third secret weapon

So do you think we've **found out everything** there is to know about our secret weapon? Hmmmm...I'm not so sure. **Take a look** at this!

▶ What **clues** do these pieces of evidence allow you to collect **about the workings of** our definitely-super-ultra-crazy-mega-powerful weapon?

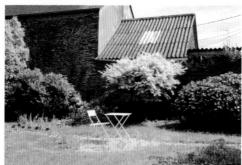

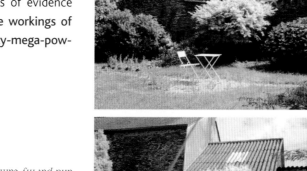

These pictures were not taken from the same height. First you see things from above, in the "giraffe" mode, because I climbed up on a bench and lifted my camera up over my head. The second photo seems to be taken from a "normal" height. The third picture looks like it was taken from the viewpoint of an ant on a blade of grass—I laid down on the lawn and put my camera on the ground.

Hint: What movement, or what photographic action, was carried out to get from one picture to the next?

Further investigation.
On the cobblestones

To confirm our **conclusions**, let's study these photos.

▶ Which **note** is **not true**? In the **first picture**:

A. The **cobblestones** are **bigger**. We see them from closer up.

B. I **crouched** down and took the picture **from** ground level.

C. The house is **bigger**.

D. The ground looks more "**packed together**."

E. You feel smaller.

Sentence C is false. 55

The secret weapon.
The final function of our weapon

Yes, as a matter of fact, this **powerful weapon** does have **one last function**. This time, it's a question of **changing our height** in order to **see things differently**!

In order to **take pictures from higher up**, hold the **camera above your head** or **climb up on something** (but be careful!). Or you can climb up to a higher floor of a house or **to the top of** a slope. This way you can show **the top of** your subject better and give the viewer a **feeling of vertigo!**

Yoohoo! I'm taking my picture from way up high!

And I'm like a tiny little kitten exploring the world.

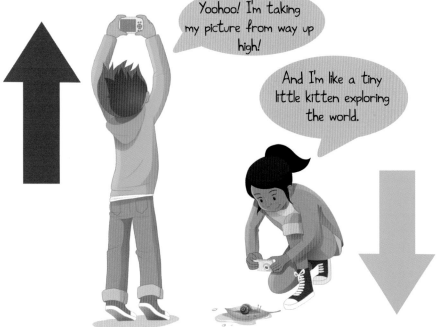

In order to take pictures from lower down, think about crouching down so you're nice and small, or even stretching out on the ground! These movements will allow you to show what's on the ground (leaves, shells, bugs) closer up and larger, or even **make it seem like you are an insect or a mouse** snooping around on the ground!

I've noticed that you often have to tilt the camera downward when you're taking a picture from higher up.

That's true! And from below, you sometimes have to tilt the camera upward a bit! It's the other way around!

We have to get used to using all of our weapons at the same time. We'll practice until we're really good at it!!

 Strategy. Using the weapon of the three dimensions

This weapon is definitely powerful! We call it the **weapon of the three dimensions** because it consists of **moving around in three different ways:**

A. from front to back, moving forward or backing up;

B. from left to right, moving sideways; and

C. from above to below, holding the **camera high up or down low**.

A B C

Considering the evidence. In the snow

▶ Let's go for a walk in the snow.

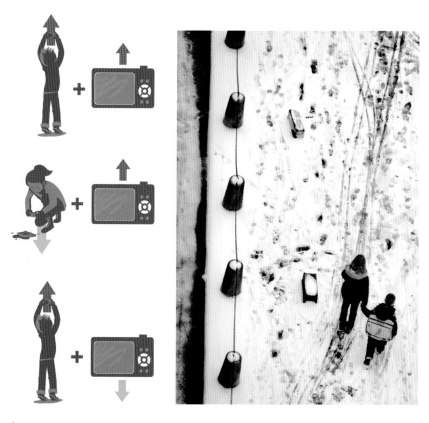

1. How would you go about taking a picture like this one? I used two different secret weapons: one of them involved my own movement, and one of them had to do with moving the camera.

2. Which set of diagrams is correct? Think carefully! If you're not sure, look for the hint on this page before you look at the answer.

to take this picture? And then would you have to tilt your camera up, down, left, or right?

1. To take a picture like this one, you have to get higher—for instance, by climbing up to a higher floor of a building—and then you have to tilt your camera downward, towards the ground.
2. The last set of symbols is correct: moving your body upward, then tilting the frame downward.

 Picture quest.
Photographic acrobatics

▶ Are you ready to twist your neck all around and crawl around on the ground to carry out the dangerous mission I have given you?! Before you go tackling these extreme situations, first try carrying out this interesting little picture quest before your marching orders autodestruct!

1. Go outside into the yard or out to the sidewalk. Lean your back against the wall of your house or your building, and then take a picture of what you see in front of you: the yard or the street.

2. Reach your arms up high, stand on your tiptoes, and climb up onto something if possible, and then take approximately the same picture from a higher viewpoint.

3. Now crouch down or stretch out on the ground if you can and take another picture from ground level.

4. Tired yet?! Go back inside, go upstairs, and take a picture of the yard or the street from a window.

5. Have fun comparing the different pictures you took!

57

Photos in disarray

 Let's investigate. We need to organize this!

▶ These pictures are all mixed up! Only Photo A is where it should be: in the first position. But what comes next? And what about after that?

1. Figure out the logic behind this series of pictures. How could they be organized?

2. Write down on a piece of paper the right order for the pictures, starting with A.

If you have any trouble meeting the challenge, look at the hint.

A

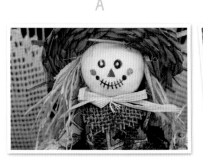

B

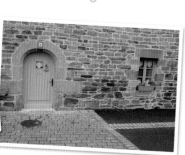

C

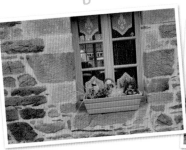

D

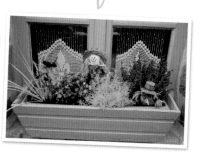

E

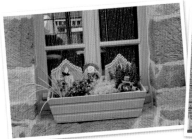

F

G

H

Hint: After I took a closeup of the doll, I slowly moved farther and farther away from the subject, creating a larger and larger frame.

1. The pictures are organized from the closest closeup to the farthest away. I backed up just a little bit before shooting each new picture.

2. The right order is A, G, D, E, B, H, C, F.

Deductions. Collecting evidence

Let's go back over the evidence that those mixed-up photos allowed us to collect. Which sentences below are true? There are only three true statements.

A. You can see the subject better when it is photographed from far away.

B. You can see the subject better when it is photographed from close up.

C. The photographer had to move forward to take photo F.

D. If you are just looking at photo A, you can imagine that the window is painted red.

E. If you are just looking at photo F, you can't tell that there is a doll in the window.

F. In photo C, the doll is the starring subject of the picture.

B, D, and E are true.

Strategy. Setting the stage

When you capture a subject from close up, you can see it really well, but you can't tell where it is.

If you take the picture from farther away, you show what's around the subject and what kind of place it is in, but then you don't see it as well!

Our mission as photographers is to find the perfect distance so that we can show the subject well and also, sometimes, take advantage of other interesting things that are around it.

You said it! I think that's a super strategy!

Yeah, I get to decide!!!

So don't let chance decide for you. It's up to YOU! You have the honor and privilege of deciding whether you are going to show the subject all by itself or in its context; whether it's going to be large or small in the picture; and whether or not you want to show us where it is!

Picture quest.

Closeup or overview?

▶ Choose a subject and take two pictures of it:

1. First take a closeup of your subject, standing very close to it.

2. Then move away from it in order to take a picture of it with its environment.

3. Which picture is better? Or maybe you like both of them?

The subtraction method

Strategy. Photo operation

In order to find the best distance from the subject, there are two infallible methods.

First, in order to get rid of all those lousy intruders once and for all, I suggest that you use—ta-daa!—the subtraction method. There is not actually any math in it, of course; our operations are strictly photographic. Subtracting just means taking away, removing, eliminating—and isn't that what we're doing when we get rid of the intruders?

Let's investigate.
Agent Jirgsby's report

This report will allow you to collect all the evidence you need in order to understand how the subtraction method works.

At 5:35 p.m. I **discover** some **flowers** in front of a **colorful door**. This seems like a **good subject**; I take a picture. [A]

On the screen of my camera…what a **disappointment! You can hardly see the flowers.** The "30" sign, on the other hand, sticks out like a sore thumb in the middle of the picture. [A]

I try to **shift my frame to the right** in order to **get rid of the sign.** [B] Good grief! I've gotten rid of the sign but now there is a **bright yellow poster** that is stealing all the attention from my pretty flowers! [B]

This time, I have to do something. **I go back to my first frame** [C] and then I take a **few large steps forward.** [D] All right now, that's much better! This **subtraction, using weapon no. 3,** enables me to **get rid of the sign, and you can see the door with the dandelions better.** [D]

A few seconds later, I make an **important decision:** I decree that the **white sign** on the door is an **intruder** (even though it is not as attention-grabbing as the yellow poster nearby) and I am going to **eliminate it from the landscape.**

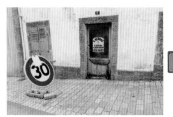

A

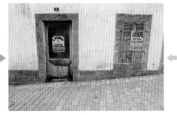

B

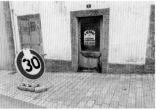

C

D

5:36 p.m. I **shift my frame downward** using **secret weapon no. 1** in order to **get rid of the intruder**. [E] The mission is going pretty well! I think the **picture** is now **safe from intruders**.

And yet, I have observed the following: the picture is still not totally satisfactory because **the flowers are still small and the ground is not that interesting**. [E] So I move a little closer! [F] I hope that I am now **close to my goal!**

I ask myself a lot of questions: Is the **gray wooden board** an **intruder**, or not? Are the **stones** bordering the door **interesting enough** for my picture? [F] With unstoppable momentum, I keep **getting closer to my subject**. I'm cutting things left and right! [G]

Now everything is happening at once! 5:37 p.m. The **yellow flowers against the blue background of the slightly flaking door** are **magnificent close up** like this. But the ground is just a **mess**! Now that I see the ground close up too, I can tell that it's completely dirty. [G]

I use the energy I have left to make **one last subtraction** and **eliminate the ground**, which is spoiling my picture. In order to do that, I **move forward** one more time toward my subject, which seems to be **pulling me toward it like a magnet!** [H]

Then I let out a **sigh of relief**. I believe **the picture is everything I hoped for!** [H] **Mission accomplished!**

Agent Jirgsby. June 23rd.

Deductions. The subtraction method

Which of the following statements represent things you're learned?

The subtraction method consists of:

A. combining our various secret weapons to simplify the photo.

B. writing a report about our picture quest.

C. eliminating the starring subject from the picture.

D. eliminating the intruding elements one by one by moving forward and tilting the frame up, down, to the right, and to the left.

The things we learned are A and D.

Picture quest.
Less and less cluttered!

▶ Here is your assignment.

1. First take a cluttered picture on purpose!

2. Find the intruding elements around the edges of the photo and for each one decide whether you want to shift the frame (weapon no. 1), tilt the camera or even use a vertical frame (weapon no. 2), or move toward your subject (weapon no. 3) to get rid of them.

3. Have you gotten rid of all the intruders spoiling your picture? Congratulations, you have successfully carried out your mission!

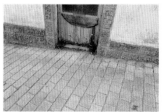 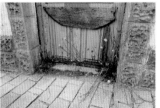 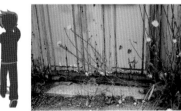 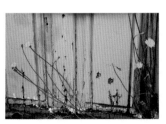

E F G H

The addition method

Strategy. Widening your horizons

Sometimes if you just take a closeup picture of the subject all by itself, the picture is kind of boring. A new strategy called the addition method can help us to widen our photographic horizons and enrich our pictures!

This time, of course, we are going to add things to a picture one-by-one.

Here are the instructions for the addition method:

1. Start with a closeup of your starring subject (a subject photographed from very close).

2. Add things to the picture one after the other by using our secret weapons, especially by shifting the frame to the side or by backing up. You must do this while trying not to add any intruding elements at the same time, of course!

3. Decide how many things you want to show in the picture. Stop when you think the picture is good and there's nothing cool left to add!

My starring subject is the blue rowboat.

Secret weapon: I move the camera upward.

I add: Water.

Secret weapon: I back up and I move the camera up even more.

I add: The bridge, the board, and the white houses. Oh no! I realize that my frame now makes you seasick.

Considering the evidence.
The rowboat and the bell tower

So the idea is to make the frame wider and wider in order to show more and more of the context, not just the subject.

For example, I chose a blue-and-yellow wooden rowboat as my subject, and then I realized that there were some elements in the area around it that could be interesting to add to my picture. So I enlarged my frame a little bit at a time to see how that turned out. Read the captions under the photos to see what was going on in my head!

Which of the pictures below do you like best?

 Picture quest. Enriching the picture

▶ Follow the addition method!

1. Take a closeup picture of your subject.

2. Back up a little and/or shift the frame, noticing all the while what this adds to your picture. If it's an intruder, backtrack and undo whatever you did in order to get rid of it! But if it's something cool and interesting, all the better!

3. Keep backing up and shifting your frame for as long as you can keep adding interesting things without having too many intruders sneak in. If you feel like your subject is getting too small in the picture, or if there are too many intruders invading the picture, go back to an earlier version that you liked and take the picture!

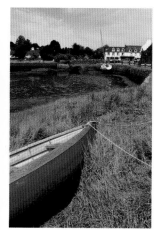

Secret weapon: I tilt my camera to the right to straighten the picture.

I add: Nothing much.

Secret weapon: I back up while shifting my frame upward.

I add: The church.

Secret weapon: I take a few more steps backward to get farther away.

I add: Part of the white rowboat.

Secret weapon: I back up even more!

I add: Some more of the white rowboat (now the whole thing is in the frame!) and a pretty little cloud.

Did you notice that when you get really close to a subject, you don't always see the whole thing in the picture anymore?

So you only get a picture of part of it... That's surprising, isn't it?! A piece of a subject! Urrrgghhh!

It makes you think that framing is sometimes a little bit like a pair of scissors that you can use to cut a picture or part of a subject out of the middle of everything you see!

The next part of your assignment will be to look at your subjects even closer up and to investigate this crazy framing/cutting.

Good luck!

You think that it's okay to just cut up your subject like that? Poor subject. Wouldn't it be better to show the whole thing?

I don't know. Photography is really a mystery! Let's continue our investigation and then we can be sure! Good grief!

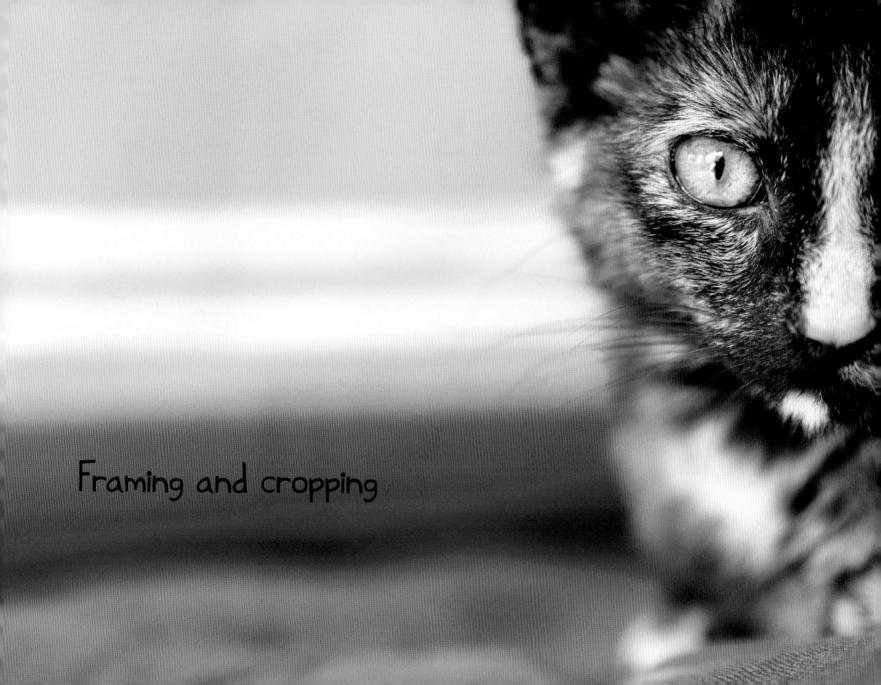

Framing and cropping

Operation crop that!

 Let's investigate! A pig on the farm

Here are some new pieces of evidence. Let's take a look at this pig...with a magnifying glass!

▶ Let's start with some very easy little riddles.

1. What is the **difference** between the two pictures of the pig?

2. Which of the pictures do you think **turned out better**?

3. Is the **better** picture:

- more interesting?
- more original?
- funnier?
- all of those things together?

A

B

1. In picture A, I only included the pig's face, from the front. In picture B, you see the pig's whole body from the side.
2. Picture A is better! Picture B is kind of boring and not pretty.
3. All of those things! The portrait of the pig with its snout full of dirt is more interesting, funnier, and more original!

66

Sometimes people think that in order to really show off their subject in the best way possible, they have to take a picture of the whole thing. Personally, I don't think that's true, because then you **don't always see** the most interesting part of the subject that well. For example, you can't really see the head of the pig in photo B.

When you want to **take a picture of your starring subject up close**, it's smart to ask yourself which part of the subject is **the coolest**! Then all you have to do is **frame the picture** so that you **just keep the good part**.

And finally, some parts of the subject are sometimes sneaky intruders or, at the very least, useless elements! For example, it's better here to keep the pig's belly, back, legs, and backside outside of the frame so that we can see its head better.

> Cropping a subject is easy! Use the subtraction method we talked about on pages 46-52 until you have trimmed away certain parts of the subject. In other words: get closer, get closer, and then get even closer!

 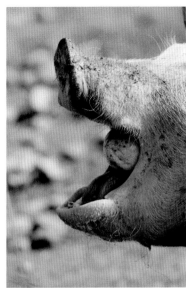

▶ Here is your assignment!

1. Choose a subject that is not too small (at least the size of a ball).

2. Decide which part of the subject is the most interesting or the funniest.

3. Crop your subject using the frame and take a picture showing only the part of the subject that you like best.

Look, my legs are dangling in the picture!

In these new cropped closeups of the pig, I focused my framing first on its eye, then on its snout (and somewhat on its ear), and then on its wide-open mouth while it was eating an apple. And I got rid of everything else. Bye-bye!

Teehee, just a foot, part of my body, and my face!

 Now you frame it. Framing on the page

▶ What if you tried to "frame some photos" on the pages of books or magazines?

Choose a magazine or book that includes large pictures, and then slide your cardstock frame around on a page to frame a variety of subjects and crop them with the frame. Decide which framing choice is best, and then go on to a new page!

Cooooool, it's fun to crop ourselves with the frame!!

Considering the evidence.
The subject in a thousand pieces

Every framing and cropping choice shows only part of the subject. But in every new picture, you can keep a different piece!

Taking a lot of pictures of different parts of the subject every time can be great fun. This is the game of the "subject in a thousand pieces."

Here is the pretty blue door I chose for this game. I took a picture of the whole thing so that I could show you what the door looks like, but whatever you do, don't tell anyone. Normally, in this game, you're not allowed to do that!

▶ On the next page, look at the pictures that I took of this door, cropping my subject each time.

1. Try to see where each part of the "subject in a thousand pieces" can be found in the view of the whole door.

2. Are all the pieces the same size?

3. Which one do you think is the most extreme close-up?

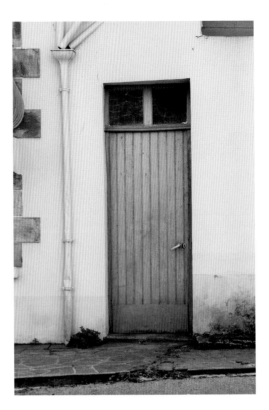

 Picture quest. Cut up your subject!

▶ Don't wait: carry out this new assignment right now!

1. Find a large subject: a door, like I used, or a window, tree, armchair, bed...

2. Take several pictures of your subject, but without EVER taking a picture of the whole thing. Think in terms of getting closer or farther away, using the secret weapon of the three dimensions in order to show smaller or larger pieces of the subject.

3. Display all of your pictures together on your computer screen if you can, or print out the best ones and glue them next to each other, all jumbled up!

2. The pieces are not all the same size.
3. The most extreme closeup is the picture of the lock.

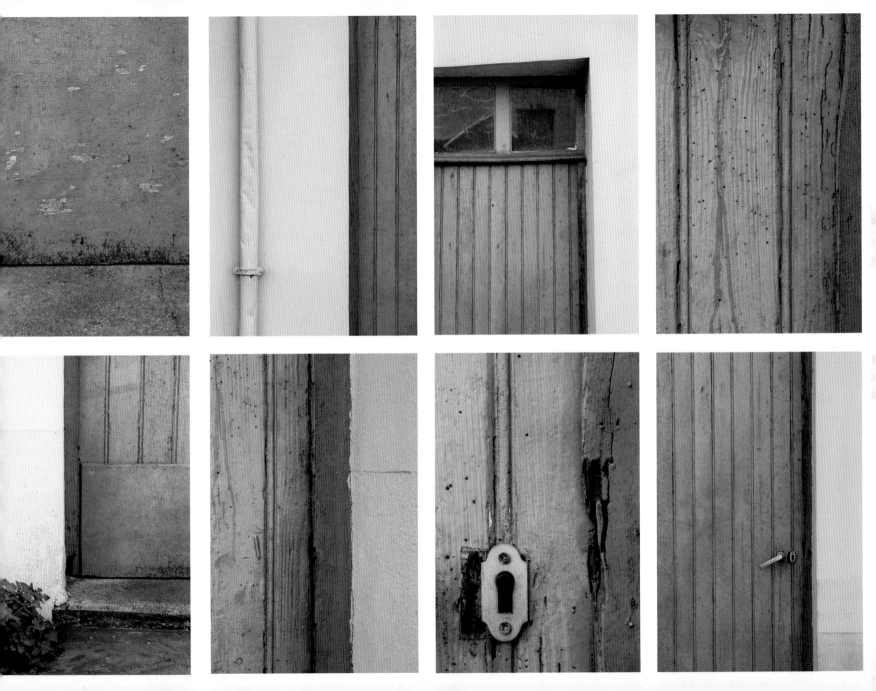

Which part should I choose?

Let's investigate.

It's a matter of choice again

When we use the frame to crop the subject in order to focus our attention on what's interesting, we have to choose which part of the subject will make the best picture.

So, are you going to make the best choice?! When I took these four square pictures of a colorful umbrella, I also had to make choices every time.

A　　　　　B　　　　　C　　　　　D

▶ Look at the pictures carefully and complete the following sentences.

1. In photos B, C, and D, I chose to show the _____, which you can't see in photo A.

2. In photos A and D, I chose to show the _____, which you can't see in the other photos.

3. Photos B and C each show two of the umbrella's _____

 In photo B I chose to show the _____ and the _____ but not the _____

 In photo C I chose to show the _____ and the _____ but not the _____

1. sky. 2. umbrella's pole (and you can also see the center of the umbrella). 3. colors. B: pink and orange but not yellow; C: pink and yellow but not orange.

Now you frame it.

Favorite subject? Forbidden subject!

▶ How about if you, too, take a picture of this little girl playing in a wheat field? She is our subject.

1. What do you think is the most important element of the subject? What do you want to focus your shot on? Take a preliminary photo with your cardstock frame.

2. Okay now, watch out: the main element that you chose for this picture (part of the little girl's body?) is now a forbidden subject and has to be kept out of the picture!

 What other part of the subject could you show by making a more daring framing choice? Go ahead and take several pictures, always avoiding the forbidden element. Try to change the direction of your shot (take at least one vertical and one horizontal picture)!

So we can choose ANYTHING then, right?!

Yesssss! This is crazy crazy crazy! We can choose what piece of the subject we keep, how big it is in the photo AND where we put it in the picture!

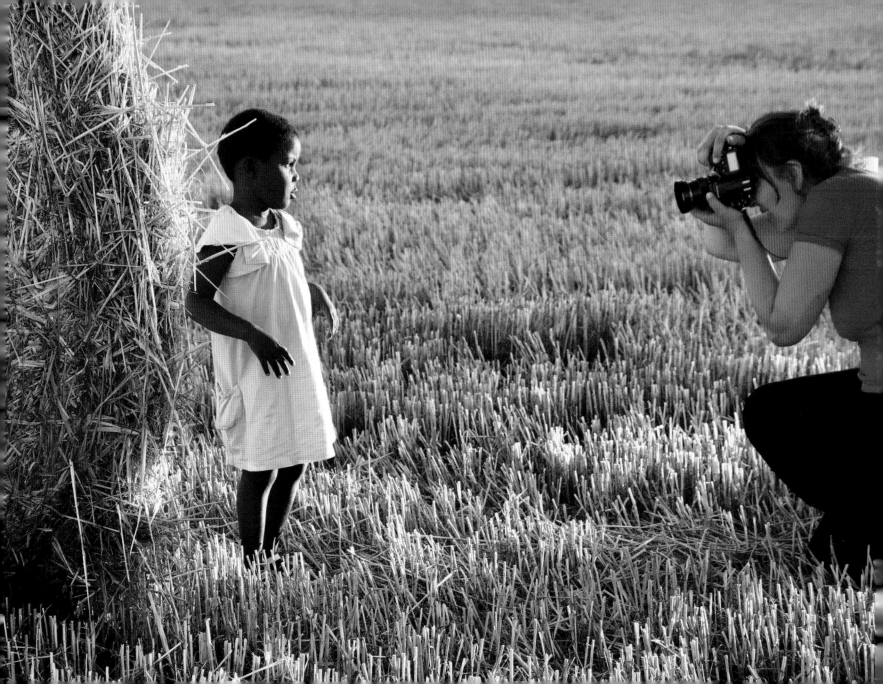

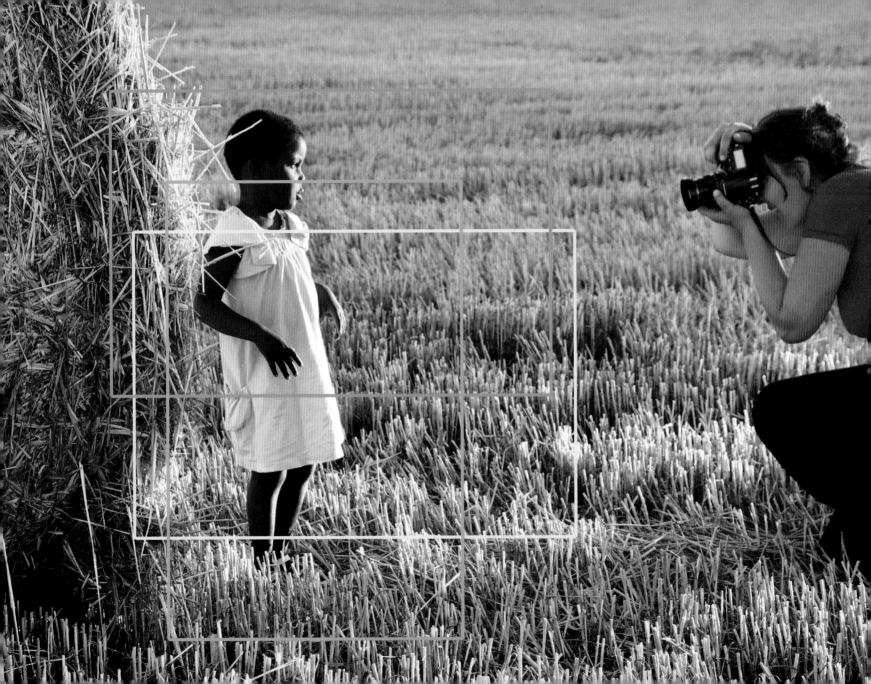

Deductions. Targeted framing choices

Here are the photos I took.

▶ Place your frame over the left-hand page to take the same pictures I took!

Finally, I also took a horizontal picture that mostly showed the little girl's hands with her polished fingernails.

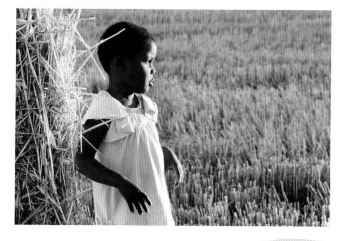

First, the element that seemed the most important to me was the little girl's gaze. So I took this picture to show that.

Then, once her gaze had become my forbidden subject, I decided to focus on her arms and legs and I used this vertical frame. I also liked the wheat field in the light (you couldn't really see that in my first picture).

Aargh! On the other hand, it would be better to avoid "decapitating" people when you use the frame to crop them right at the neck.

In the first picture, you mostly see the little girl's face. But when you take away a person's head or even just her eyes (as I did in my other pictures), you begin to pay more attention to the gestures the person is making with their hands, the posture of their body, their clothes, or other things like the nail polish in this picture. Every picture tells a new story!

Yes, it's better to crop right under their eyes or at their shoulders or chest, for sure!

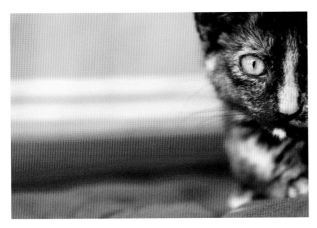

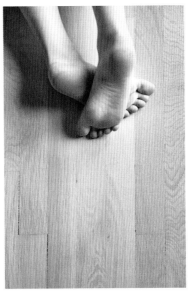

Strategy.

Daring frames!

When you photograph only part of a subject, don't always keep the most obvious piece, like a person's head or the door of a house!

Isn't it more fun and more unusual to sometimes photograph only a person's feet or just part of a wall of a house? Or the snout of a pig?!

In these pictures, I focused my frame on whatever pleased me the most in my subject: a pretty star-shaped earring and two feet crossed over each other on a wooden floor.

And what about the cute little kitten?! I cropped its head between the eyes to make a comical picture and to leave some room for the cool colorful stripes of the cushion next to the kitten!

Picture quest. Use framing to crop your family and friends!

▶ And what about you: how are you going to photographically crop your buddies, your brothers and sisters if you have any, or even your parents?

1. Choose somebody you want to photograph.

2. Decide which part of their body, which piece of clothing, or which piece of jewelry could be the starring subject of your picture. It could be a barrette in their hair, the color of their eyes, their hands while they are cooking, a lock of hair, some funny socks...

3. Take a picture that crops the person's body and shows the starring subject that you chose.

4. Now take another picture, focusing on a different detail.

What if you made a "person in a thousand pieces," like on page 69?!

A piece of cake... or of the subject?!

Let's investigate! Cropping the subject

If you're too greedy and you eat an entire enormous cake, you're sure to get a stomachache! And in photography, it's the same thing: taking a picture of the whole subject does not always lead to the best results!

Let's see HOW we can crop our subjects with our camera.

There are so many possibilities!

First let's crop a piece of the subject as if we are cutting a piece of cake or pie. Hmmm, that looks tempting, doesn't it?

Let's keep our observations confidential using coded documents, like on page 43!

▶ Which coded document corresponds to the framing of my piece of pie?

A

B

C

It's drawing B! The piece of pie goes all the way out to the edges of the frame and is right in the corner of the picture.

75

Strategy. Corner framing

When you crop a subject this way, the piece of the subject that you keep is positioned in the corner of the frame. I call that "corner framing" or "piece-of-cake framing."

Here is my picture again, with the right coded document.

When you take the picture, choose which part of the subject you want to keep in the frame, and then crop the subject by putting that piece in the corner of your picture! We are going to learn how to do that on page 78. So, which piece of the pie do you want to gobble down?!

Let's investigate!

Variations on corner framing

When you use a "piece-of-cake frame," you can also decide which corner of the frame you want to put your piece of the subject in!

Look at these pictures. I put my cropped subject in a different corner of the picture each time: in the upper left, in the lower left, in the lower right, and in the upper right.

Considering the evidence.

A corner of the umbrella!

Go back to page 70 to look at the pictures of the umbrella.

Which of the pictures use corner framing?

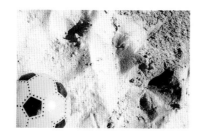

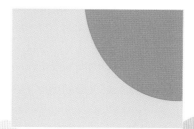

▶ There are four different coded documents:

A. because there are four seasons in a year.

B. because a picture has four corners.

C. because cats have four paws.

Answer B! Because a picture has four corners, of course!

Pictures B, C, and D are corner-framed pictures!

Further investigation.
Come on, into the corner!

This works with a vertical format too, of course!

▶ Connect each coded document to one of the vertical photos.

A B C D

Notice that corner framing is not just for round subjects! You can cut a piece of any subject at all using the corner of the frame, like I did with the dog or the woman in red!

A: the tree stump; B: the dog; C: the purple flower; D: the woman in red.

Strategy. Corner framing

The following instructions will help you to use your secret weapons so that you can successfully use corner framing.

First frame your subject so that it's in the center of your picture, the way I have framed this jam jar. The subject needs to be relatively large in the picture.

Using weapon no. 1, shift the frame in two directions at once (or diagonally) so that your subject moves toward one of the corners of the frame.

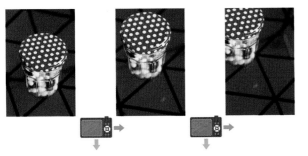

Keep shifting the frame in the same way until part of the subject is outside of the picture and the piece that is still inside the frame is in the corner of the picture, cut like a piece of cake!

Now you frame it.
The sunflower

▶ Use your cardstock frame to corner-frame pieces of the sunflower on the next page. Take horizontal and vertical pictures and remember to position your flower piece in different corners of the frame!

You think that's easy? But can you find at least five different ways to corner-frame this sunflower?

Yeah! I actually found seven different ways to frame it! I'm so greaaaaaat!!!

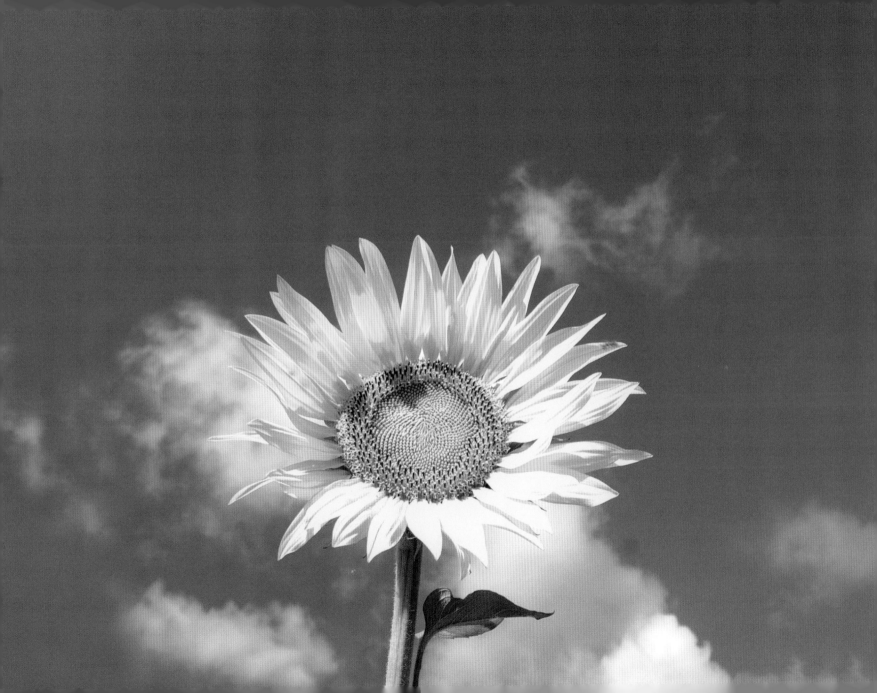

Deductions. Like a sun

There are so many possible ways to frame this! Do these framing choices look like what you did?

Here is the subject in the bottom right corner:

Here is the subject in the bottom left corner:

Here is the subject in the top right corner:

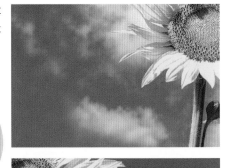

I wanted to frame the bottom of the sunflower vertically as well, but there wasn't enough room: the cardstock frame went off the edge of the page that way!

Here is the subject in the top left corner:

All of these pictures were made with the frame held straight (horizontally or vertically), but it also could have been tilted, of course!

▶ Now corner-frame the sunflower with your frame tilted!

 Picture quest. Cutting off a piece

▶ Your turn!

1. Choose an object that is not too small: a ball, a plate, a cereal box, a book...

2. Put it on the ground or on a table with nothing around it.

3. Use your camera to take a corner-framed picture of your subject, or even several of them!

Other ways of framing...

Let's investigate!

Variations on corner framing

I do think that corner framing is my favorite kind of framing, and it offers so many possibilities! But there are other kinds of framing that are also very cool.

▶ Take a look at these new pieces of evidence!

1. Did I use a corner of the frame to crop this hamburger and this rooftop?

2. What part of the frame did I use to crop my subjects this time? Imagine what kind of coded document would correspond to each of these pictures—or better yet, try to draw the coded documents on a piece of paper.

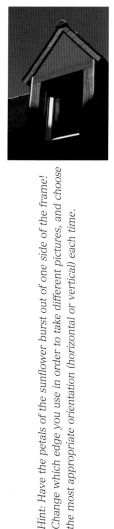

Now you frame it.

The return of the sunflower

▶ Try to crop the sunflower on page 79 using the same kind of framing as I used here for the hamburger or the rooftop. Have the petals burst out of one side of the frame!

Can you take several different pictures?

Hint: Have the petals of the sunflower burst out of one side of the frame! Change which edge you use in order to take different pictures, and choose the most appropriate orientation (horizontal or vertical) each time.

1. I did not use a corner of the frame to crop the hamburger or the window. 2. I used an edge of the frame!

 ## Deductions. Cropping with the edge

This time the subject is cropped using one of the sides of the frame, not the corner.

The hamburger is cropped using the left edge.

The rooftop is cropped using the bottom edge.

And here's what you get if you crop the sunflower using the left edge and the right edge on vertical pictures and the bottom edge on a horizontal picture. These pictures are fun, aren't they?!

In the coded documents, the subject is always represented by a circle: that makes things much simpler!

 ## Strategy. Shifting to the edge

Cropping the subject using just one edge of the frame is even easier than corner framing! All you have to do is shift the camera toward the piece of the subject that you like best.

Here, what I liked was the red triangle above the window, so I just kept pushing my camera up and up and up toward the triangle until the rest of the subject had disappeared out of the frame. And there you have it!

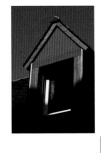 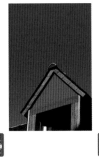

Picture quest.
A piece of the subject on the edge

▶ Use your camera to take pictures of pieces of subjects emerging from the edge of the frame: the top of a tree, a piece of your pencil case or a sandwich, or part of a leaf, shell, or stone...

Be careful: your subject should not touch the corner! Only one of the sides!

Oh yeah?! Even when the subject is triangular? Teehee! What an idea!!!

A new way of cropping?!

Let's investigate! Yummy subjects

Notice how these delicious subjects are cropped by the frame using: a corner? an edge? something else?

If you're not sure you have figured out how each of these was cropped, imagine or draw the coded document that would go with each picture, or use your finger to find the spot where the subject touches the frame.

Now solve these riddles! Write down the letter (or letters) of the photo (or photos) that corresponds to each of the answers below.

1. How many subjects were cropped using just one edge of the frame?

2. Which photo shows two subjects cropped the same way?

3. Which photo shows a subject that is not cropped at all?

4. How many photos show corner framings?

5. Which photo shows a subject that is cropped in a different way from what we have seen so far (it is neither a corner framing nor is it framed using one of the edges)?

A B C D E

F G H I J

1. Three of the subjects are cropped using just one edge of the frame: A, G, and J.
2. Photo B. Each of the pastries is cropped in a corner.
3. In photo E, the apple is not cropped at all by the frame.
4. Five of the photos use corner framing: B, C, F, H, and I.
5. The picture of the cabbage (D)! It looks as though the subject has been cropped by two corners of the frame, one entire edge, and small parts of two other edges.

Considering the evidence. The riddle of the 24 pictures

We have just found an explosive file worth its weight in gold! It contains 24 pieces of evidence about cropped frames. What luck!

Unfortunately, everything is all mixed up. It's up to you to get all of it organized again. Come on, there's work to do!

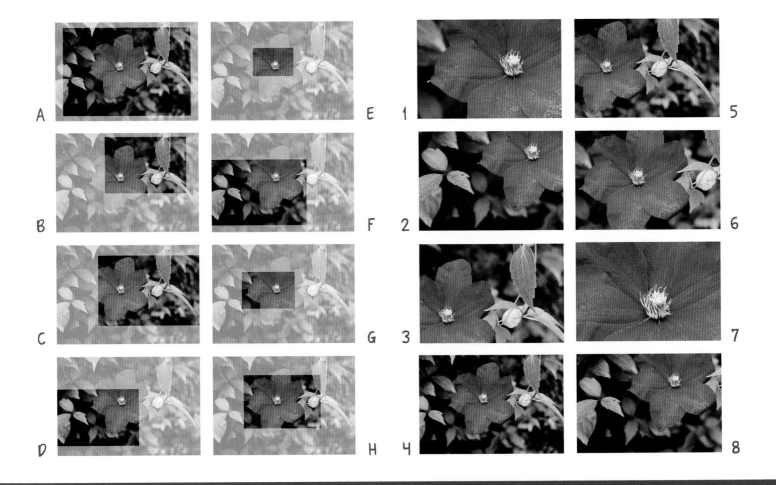

▶ Organize the evidence by grouping the files into sets of three: connect the framing choice, the final picture, and the coded document that correspond to one another to form a set.

For example, frame A shows the whole flower, uncropped. In the second set of files, which photo also shows the whole subject? And finally, in the third set of files, which coded document corresponds to the frame that doesn't crop the subject?

On a piece of paper, write down the letter, the number, and the symbol for each set of three files. Good luck to you!

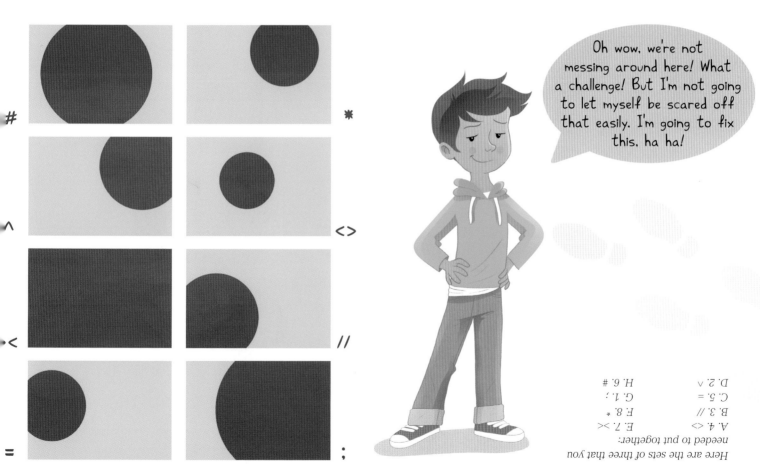

Oh wow, we're not messing around here! What a challenge! But I'm not going to let myself be scared off that easily. I'm going to fix this. ha ha!

Here are the sets of three that you needed to put together:

A. 4. <>	D. 2. ^
B. 3. //	C. 5. =
E. 7. ><	G. 1. ;
F. 8. *	H. 6. #

Hint: Look closely each time and notice where the subject is located in the picture, the shape of the flower within its frame, and where the flower touches the frame. Take your time and it will work out!

Further investigation.
Flashback evidence

▶ **1.** In the tilted photo on page 37, how is each piece of fruit cut up?

2. In the pictures of the blue door in a thousand pieces (page 69), how many of them are corner-framed?

3. In each of the three pictures on page 73, how many edges is the little girl touching each time? Specify which edge it is in each case (left, right, top, or bottom).

1. Each piece of fruit is cropped by a different edge! What an interesting way to frame this!

2. Two of the pictures are corner-framed: the third one and the fifth one.

3. In the first two pictures, the little girl is touching one edge of the frame: the lower edge with her dress, and then the upper edge with her head. In the third photo, she is touching both the lower and upper edges!

Deductions. The correct conclusion

Find the correct conclusion below, hidden in the middle of all these ridiculous statements!

A. A subject that touches the top and bottom edges of the frame is corner-framed.

B. The subject does not have to touch the edge of the frame in order to be cropped by the frame.

C. When you crop the subject with the frame, you don't see anything BUT the subject, and you don't see the larger context anymore at all!

D. You can always find at least five ways to crop the subject.

E. There are ways to corner-frame that show the whole subject.

The correct conclusion is sentence D.

Now you frame it. Coded frames

▶ Now it's your turn to do some framing! This time an old sign painted on a garage door is going to lend itself to our framing game.

Your mission is very simple. Using your cardstock frame, frame your picture in six different ways corresponding to the mysterious encrypted documents below!

Ha ha ha, this is really just a bunch of nonsense!

Deductions.

No sign of trouble here, I hope!

So, were you able to frame your pictures in all those ways? Did you even manage to match the strange all-green document that didn't show the subject at all?!

Here are the solutions to this challenge.

Go back to the previous page and use your cardstock frame to see what these pictures look like full-size, and to reframe any of the ones that gave you trouble.

Picture quest.

The six-frame game

▶ Try to take real pictures that match each of the coded documents from the game with the old sign.

You can take several pictures of the same subject or change your subject for each of the framing assignments; it's up to you.

1. Examine the coded documents on page 86 and choose which one you want to start with.

2. Find a subject that would work for the coded document you chose.

3. Carefully frame your subject, then take your picture!

4. Choose another coded document and continue the process. Keep going until you've taken a picture for each coded document!

Mystery photos

 Let's investigate. Mysterious, mysterious!

Are you all set now? Not afraid to cut up your subjects into pieces and dare to frame them in more interesting and original ways?!

Let's continue on this path!

See these beautiful pictures I took?

▶ In a few moments, I am going to reveal my secret to you and you, too, will be able to create beautiful, mysterious pictures. But first, you have to look for some evidence.

1. Can you guess what the four subjects are that I photographed here?

2. Even if you can't really tell what the subjects are, how would you say I cropped them? Where do the subjects touch the frame?

 Try to solve the riddle before you turn the page!

Deductions. A variety of subjects

Did you recognize them? My mystery photos are closeups of a shell, a banana leaf, an onion, and some jam!

In the mystery photos (turn back to the previous page to look at them again if you need a refresher), each subject touches the frame...everywhere! Each subject is cropped at every corner and every edge of the frame!

Strategy. Deep-inside framing

I used "deep-inside" framing here to allow me to make these pictures so mysterious. For this kind of framing, all you have to do is crop your subject on ALL sides. The picture shouldn't show the edges of the subject nor anything around it! It's easier to do if your subject is reasonably large.

With this kind of framing, you can't tell what shape the subject is. All you are photographing is its color, its texture, and its details—you go "deep inside"! The picture looks a little like a painting. Sometimes it's really hard to figure out what the subject is, and it becomes a mystery photo!

See how surprising the coded document that corresponds to a deep-inside frame is.

This time the subject touches the frame everywhere and all you can see is pink!

The all-green coded document on page 88 had NO subject. This one has ONLY the subject!

> Cropped at ALL the edges and ALL the corners of the frame?! Wowwww! I call that framing!!!

Picture quest. A piece of clothing is the star!

▶ Lay one of your favorite pieces of clothing on your bed, a chair, or the floor, close to a window, if possible. Take a picture of it without showing the edge of it (or anything around it). Just frame the fabric itself, maybe with some buttons, part of a pocket, some stitching, or another detail.

Considering the evidence.

Material photos, mystery photos!

These new pieces of evidence will help you to understand our strategy even better and to find ideas for subjects that you can make mysterious.

▶ Connect each of these mystery photos to its corresponding wider view. Write your report on a piece of paper!

A D

B E

C F

The answers are:
A5, B2, C6, D1, E3, F4.
If you weren't able to match up some of the pairs, go back now to find where the "mystery zone" is located in each of the numbered pictures.

Framing and cropping

1 2 3

4 5 6

📷 **Picture quest.**

Now you create the riddle!

▶ Your mission is to create mystery photos!

1. Look for subjects that are not too small and that are made out of interesting materials: plants with large leaves, doors and walls that are a little run-down, large stones, fruits, vegetables, cookies, bread...

2. Take pictures of your subjects without showing their edges. Get close to them so that you can take extreme closeups (think of the macro mode on page 5)!

3. Get your family or friends to guess the subjects of your pictures!

> If the picture is blurry, that means you are too close! Back up a little. If that makes the edges of your subject show in the picture, you need to find a bigger subject!

There! Phase A of the project is now finished! You have met the challenge of framing with talent. Good for you!

We have chased away pesky intruders and learned how to choose what subjects and parts of subjects we want to keep in our frame. In a nutshell, we have sifted our material and only kept what we really like.

And after the sifting comes the organizing! In photography, we call this composition. It means organizing our subjects in the picture in such a way that the picture is neat and orderly and you can find everything in it. And that is phase B of our plan of attack!

Well, gee! How can I say this... ummm, organizing is not really my thing, I'm afraid...I'm not very good at that.

Oh, don't worry! A picture is a lot smaller than your room!! I'm sure you're going to be a pro at "photographic organizing," in other words, at composition!

You think so? Okay, well, there's only one way to find out...here we go to chapter 5!

Compositional strategies

"Photographic organizing"

🔍 Let's investigate. Red, yellow, blue

Our first piece of evidence in this chapter is this closeup of a modern building with colorful walls. I had fun cutting it up like a puzzle in order to study its composition.

▶ Examine the picture.

1. What is the starring subject of this picture?

2. Where is it positioned in the photo?

> Oh, this is fun! You can see the reflection of the photographer in the picture! Can you find it?

1. The starring subject is the red arrow.
2. It's in the top left corner of the picture.

🔑 Strategy. Composition—what's that?

Composing a picture can be something like asking yourself where you are going to put the subject in the picture. If you look at the picture and feel like it's well-organized, you say "what a cool composition!"

When you are trying to decide where to put the subject, which "drawer" you are going to put it away in, it can help to imagine that you are cutting the picture up into pieces.

So here again, we are going to be thinking about the edges and corners of our photos!

▶ This colorful drawing is like a vertical photo, divided up into puzzle pieces. Let's examine it more closely!

1. Find the puzzle pieces that are in the corners.

2. Find the puzzle pieces that are on the edges (but not in the corners).

3. One of the puzzle pieces is neither on an edge nor in a corner. Which one is that?

1. The dark green, yellow, dark orange, and light purple puzzle pieces are in the corners.
2. The light green, light orange, pink, and turquoise-blue puzzle pieces are on the edges.
3. The dark purple piece is not on an edge or in a corner: it is in the center of the photo, or you could also say "in the middle."

Considering the evidence. What doesn't belong?

▶ Look carefully at the composition of these various pieces of evidence.

1. What is the **starring subject** of each of these pictures? **Where is it?**

2. One of the pictures does **not** have **the same composition** as the others. Which one **doesn't belong?**

the lower left of the picture.
2. The picture with the car is the one that doesn't belong because its subject is at
flower. The subject is at the lower right in almost all of the pictures.
1. The subjects are: a snail; an old man and his dog; a bird; a car; and a purple

Let's investigate. How shall we do this?

In order to compose our pictures well, we have to decide where we want to put the subject. But how should we go about moving the subject around within the picture and putting it in the right place?

▶ These two pictures of raspberries will surely help set you on the right path.

1. Where is the subject in the first picture? And in the second one?

2. I bet you can guess what I did in order to move the raspberries within the picture! So, what **photographic action** did I take?

2. In order to move the subject within the picture, all I had to do was shift the camera! This is our secret weapon no. 1!
upper left corner of the second one.
1. The subject is in the middle of the first picture, and in the

Moving the subject?

Considering the evidence. Let's go back

Let's go back and take another look at chapter 1 just so we've covered our bases!

1. Look at the photos of the tractor on pages 24 and 25 again. Does it seem to move within the picture when we change the framing?

2. And what about the bell tower on page 26? What do you think?

3. And our last piece of evidence: Does the cow on page 31 confirm your intuition?

Yes, the subject moves within the picture every time we change the framing!

Strategy. Changing the composition

So once again, we can change our pictures and make them better by moving our camera up, down, to the right, or to the left; in other words, in every direction! This time, this is going to help us to move the subject within the picture and choose where to place it for the best composition!

Oh yesssssss! How did I not notice this sooner?!

I think I actually had noticed it.

For example, I made these two very different compositions, showing a little white house at the edge of the sea, just by moving the camera. At first, the house is at the lower left and we see a lot of sky. In the second picture, the house is at the top right of the frame and suddenly we see the sea, which is right in front of the cliffs!

Now you frame it! Move your subject

▶ Get your cardstock frame and start playing around!

1. Frame the silhouette.

2. Move your frame to different sides in order to make the subject move around within the picture!

3. Make as many different compositions as you can by changing the position of the subject within the frame and the orientation of the photo.

4. Now create these compositions:

 – a centered horizontal composition with the silhouette right smack in the middle;

 – a vertical composition with the silhouette at the bottom of the photo; and

 – a horizontal composition with the silhouette at the upper right.

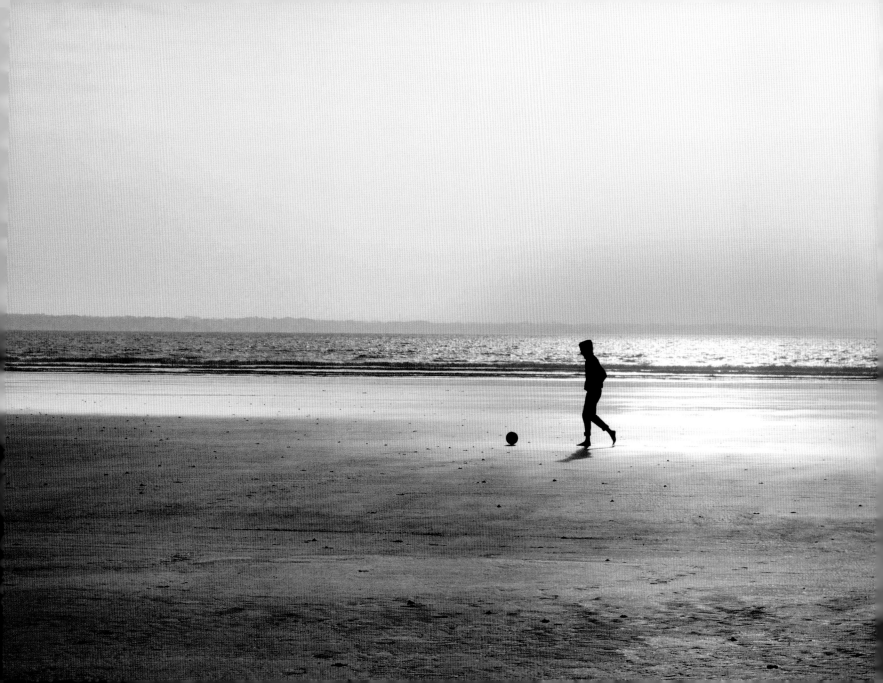

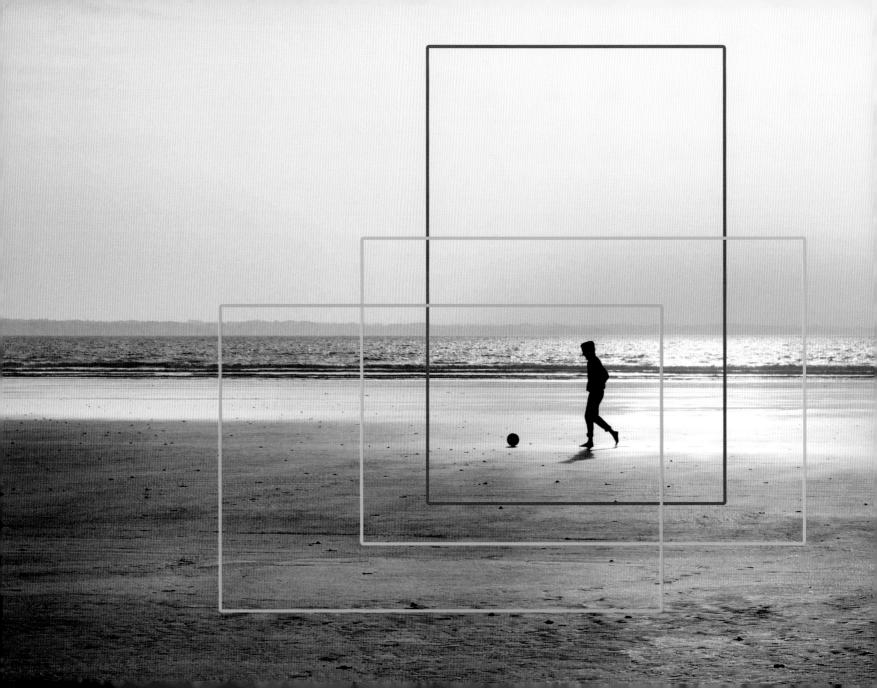

Deductions. Three kinds of composition

So how many different compositions were you able to find?

By using both vertical and horizontal framing and putting the subject in the position of each of the different pieces of my puzzle, I created eighteen different compositions! Crazy, isn't it?!

▶ Here are the pictures that were specified in question 4 on page 96.

Position your frame on the picture on the previous page and follow the colored outlines to get the exact same frames that I did, if you like!

Centered horizontal composition

Horizontal composition shifted toward the top right corner

Vertical composition shifted toward the bottom of the picture

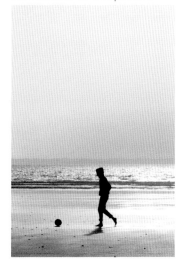

If you didn't find very many different compositions this time around, feel free to come back and try the game another day, or even right away!

So these photos show three different compositions that you could find. Do you like one of them better than the others?

 Picture quest.

The wandering subject

▶ And now, with the camera!

1. Choose a subject that is small enough that you will be able to move it around within the picture without it leaving the picture too quickly.

2. Move the camera in front of the subject and watch how the subject moves within the picture.

3. Take the picture when you've found the composition you like the best!

Nailed it!

 ## Let's investigate.

"Mission paraglide" launch!

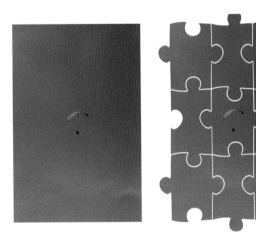

Are you ready for "Mission Paraglide"?

For every type of composition, this pretty orange paragliding sail is going to "pose for the picture."

▶ Let's analyze this composition!

1. Where is the subject within the picture? What is this kind of composition called?

2. Do you have the feeling that:
 – the paraglider is more or less immobile in the sky?
 – the paraglider is moving? If it seems to be moving, which direction would you say it's going? To the left, to the right, up, down?



1. The subject is in the middle of the picture. This is a centered composition.

2. The paraglider seems to be immobile in the sky. It could be going into the direction of any of the puzzle pieces surrounding it, but there is no way to know which one. In fact, it looks more like it's just going to stay where it is.



 ## Deductions.

A subject that is a little lost

In a centered composition, the subject seems to be standing still and looks a little lost in the middle of the picture.

So it's not at all the best composition for our photos.

Wouldn't you rather have compositions that are full of movement and make your starring subjects come alive?

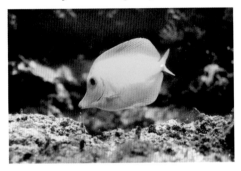

Huh. It's almost like the subject is just kind of stuck there in the middle of the frame and doesn't know where to go.

Directed compositions

 ## Let's investigate. "Mission paraglide," continued

Let's free our subject and let it leave the middle of the picture in search of new horizons!

▶ Here is our paraglider again! Let's ask the same questions we asked before.

1. Where is the subject? What could we call this kind of composition?

2. Do you have the feeling that:

 – the paraglider is more or less immobile in the sky?

 – the paraglider is moving? If it seems to be moving, which direction would you say it's going? To the left, to the right, up, down?

2. This time it looks like the paraglider is going to move across the picture. I imagine it flying gently to the right.

1. The subject is at the left edge of the picture. You could call it a composition "on the edge," or a composition "shifted to the left."

Considering the evidence. The mystery composition

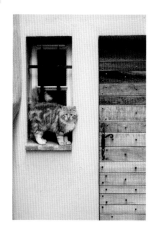 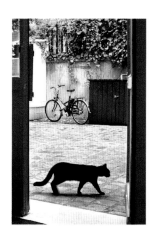

That's funny, each of these little cats is positioned next to an edge of the picture!

▶ Now imagine a fourth picture, showing a white cat that has chosen a different edge than any of its buddies. Where would it be positioned within the picture?

The ginger cat is on the left side of the picture, the black cat is at the bottom of the picture, and the gray kitten is at the top of the picture. We're missing a composition in which the subject is at the right. The fourth picture would show a white cat on the right side of the picture.

Strategy. Some space for your subject

Position your subject next to one of the edges of the picture in order to give it some space and to make your composition livelier and more dynamic!

You know how to do this, of course, using secret weapon no. 1! You can compose your picture with the subject positioned at the top, bottom, right, or left.

Because the subject has space in front of it, you can almost imagine it moving around in the picture!

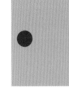

Here, the vertical format with the composition shifted toward the bottom allows me to include some blue sky to go along with the yellow car!

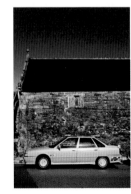

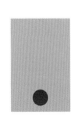

Now you frame it! Choosing your edge

But there is still one more mystery to solve on the subject of off-center compositions: How can we choose which edge of the frame to shift the subject toward?

As you have probably guessed, some choices are better than others, and it depends on the subject! Let's see how it works with this white pony grazing in a field.

▶ Your mission is to use your frame to take a variety of horizontal pictures of this pony. Off you go!

1. Start by taking a horizontal photo with a centered composition.

2. Then take four horizontal photos with your composition shifted toward one of the edges: one with the subject to the right, then to the left, then to the top, and then to the bottom of the picture.

3. Examine each composition carefully and ask yourself whether the pony can in fact "move around in the picture." So which composition looks best to you?

Don't stick your subject too close to the edges, though! It shouldn't touch the frame. Leave a little bit of room all around it so that it can "breathe."

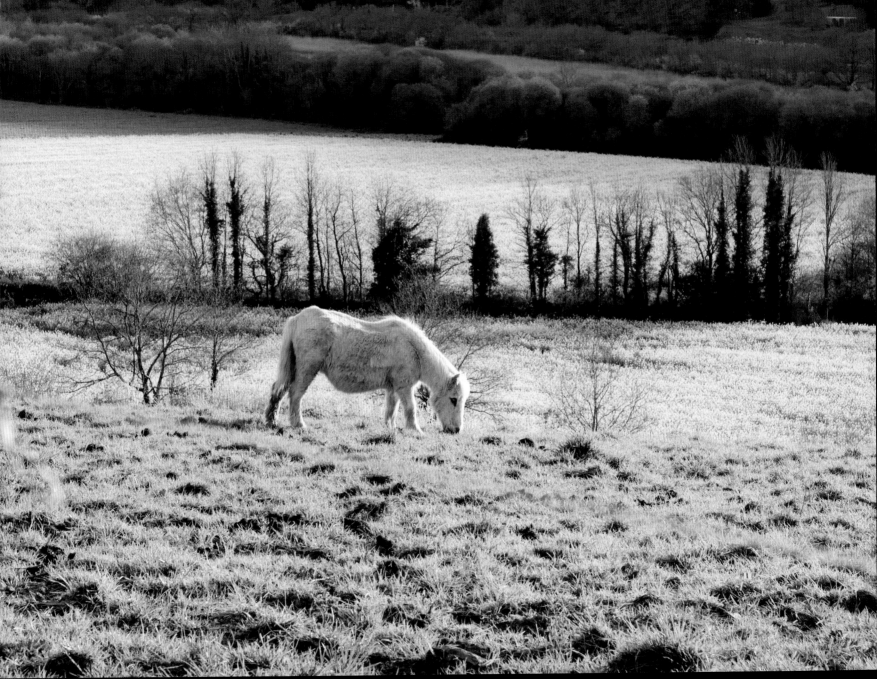

Deductions. Compositional variants

Let's leave aside the centered composition, because it's not very original or dynamic, and concern ourselves instead with the compositions that are shifted toward one of the edges of the frame.

Subject at the right of the picture

Here it looks like the pony is going to walk right out of the picture or hit its head against the edge of the frame! This is not ideal. There isn't enough room in front of the pony for us to imagine it walking through the picture.

Subject at the left of the picture

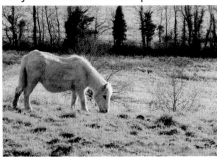

In this composition, the pony can move forward in the picture without bumping up against the frame. I can almost see it already grazing on the lovely tufts of grass just ahead of it! This is a nice composition.

Subject at the top or bottom of the picture

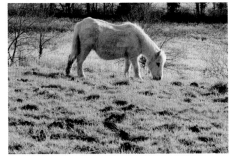

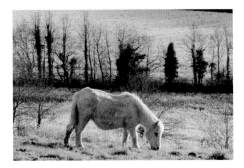

In these two compositions, the pony has as much space behind it as it does in front. So we can imagine it moving forward in the picture, but only a little bit.

The difference between these two pictures is mostly the landscape around the pony: green grass or a field of yellow rapeseed!

Do you prefer one of these two pictures over the other?

Composing in the direction of the gaze

Oh boy, one more thing that goes backward! If the subject is turned to the left, we position it on the right side of the picture! And if the subject is turned to the right, we position it on the left, of course!

Strategy. Composing in the right direction

In order to decide how best to compose a picture, first notice the direction in which the subject is moving or the direction in which it is looking, and then leave some room in FRONT of it!

Since our pony is facing the right, it is better to position it at the left of the picture so that it can have some room to walk around in the picture.

On the other hand, in order to take a picture of this girl walking on the beach, I had to compose in the other direction in order to leave some room in front of her! I put her all the way at the right of the picture.

And finally, if the subject is facing you or has its back to you, then you can compose it however you like!

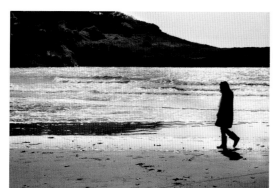

Let me guess what comes next. If the subject is facing upward, we put it at the bottom of the picture! And if it's facing downward? We put it at the top, of course! It's not that hard to compose pictures after all.

Considering the evidence.
The flight of the moth

▶ Let's look at this moth as a further contribution to our investigation.

1. How do you imagine it would move if it left the glass it's resting on? What direction would it go?

2. How should we compose a picture with this moth? Where would you position the subject? Imagine or draw its photo puzzle before you turn the page.

When the moth leaves its perch, it will fly up toward the sky, of course! So I positioned it at the bottom of the picture so it could have room above it to fly away.

What do you think of this composition?

 Let's investigate. The gaze of subjects that don't have faces

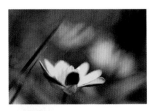

Hmmm, what about a flower, a house, or a musical instrument: these aren't looking in any direction, are they?! I think these two pictures of yellow flowers will give us some new clues. Look at them carefully.

▶ What is our evidence here?

A. The second flower seems to be looking to the right.

B. It would have been better to place each flower more in the middle of each picture.

C. You can't compose according to the direction of the gaze with flowers.

D. Flowers don't have eyes, and yet it does often seem as though they are looking in a particular direction.

E. The first flower seems to be looking up, so it was a good idea to place it at the bottom of the picture.

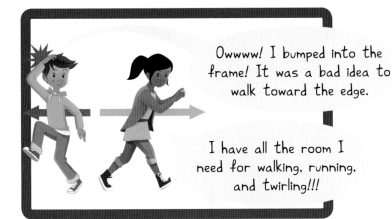

Owwww! I bumped into the frame! It was a bad idea to walk toward the edge.

I have all the room I need for walking, running, and twirling!!!

Now you frame it! Direction of movement

▶ Let's go back to the beach!

1. Notice what direction the people in this picture are facing (the driver of the sand sail is seated at the back). Are they mostly turned to the right or to the left?

2. Choose a starring subject, and then compose your picture according to the direction of that person's gaze. The person needs to have room in front of them so that they can move around in the picture (they shouldn't bump up against the edge of the frame)! Do the same thing with a few different subjects.

3. Now try to compose the pictures VERTICALLY, showing ONLY the subjects who are looking toward the interior of the picture.

If you find this activity difficult, look at the answer to question 1 before you compose your pictures!

1. *The man with the red hat, the young woman, and the person driving the sand sail are turned to the right. Let's position them at the left of our compositions! The boy with the plaid shirt and the person walking to the right of the buoy are looking to the left, so it makes sense to put them on the right! The child with the hoodie has his back to us; he could be placed anywhere in the picture.*

Sentences A, D, and E are our new pieces of evidence.

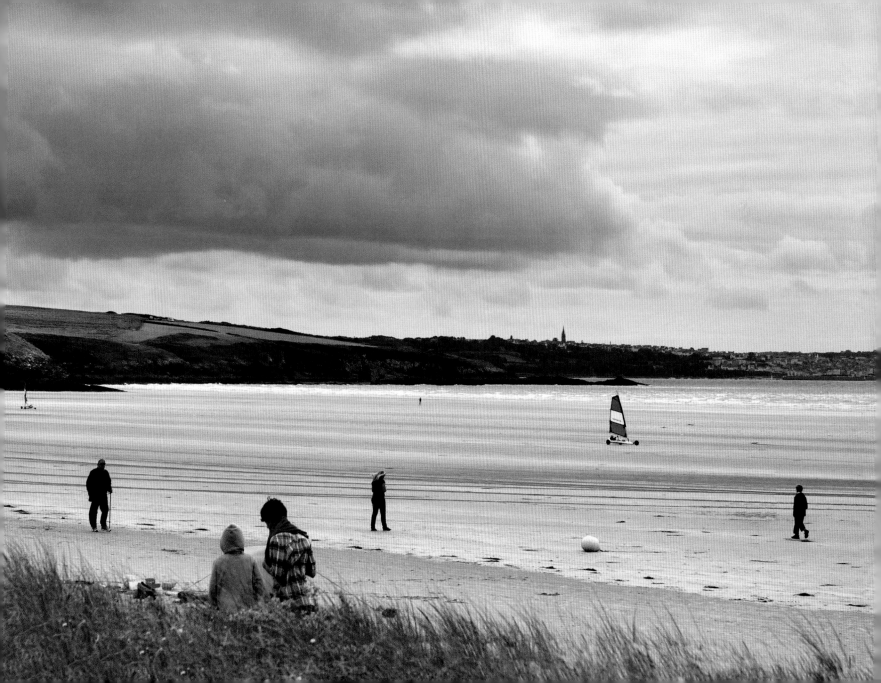

Here are the first three pictures I took of this scene.

1. This first picture shows the man with the red hat and cane at the left of the composition and the boy with the checked shirt at the right. Both of them have plenty of room in front of them, and they are looking toward the center of the picture. That's good!

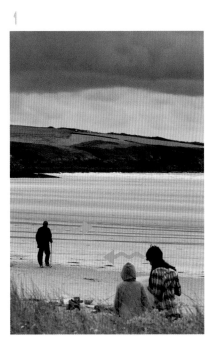

3

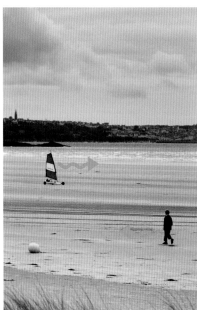

3. I positioned the sand sail at the left of my third picture, and this time it has room in front of it so it can sail across the beach! The person walking all the way at the right of the scene is also moving toward the center of the picture, so the composition is great! It looks like the two subjects might be crossing paths soon.

2. On my second try, I positioned the young woman with her hair blowing in the wind at the left of the picture, so that she would have room to walk forward. However, this composition has a problem because the sand sail does not have any room in front of it, so it looks like it is leaving the picture.

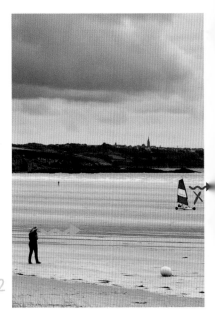

2

Picture quest.

Composing in the right direction

▶ Now it's your turn to compose in the direction of the gaze!

1. First choose a subject with a face (a person, a stuffed animal, a doll, or a little statuette or action figure). In what direction is the subject looking?

2. Compose your picture so that the subject is looking into the picture and its gaze is not bumping up against the edge of the frame.

3. Now try this with a subject that does not have a face (a flower or some object, for example). Try to figure out which direction it seems to be looking, and compose your picture in the right direction.

The subject in the corner

🔍 Let's investigate.
The paraglider's last flight

▶ One last time, let's ask ourselves the same questions about the pieces of paragliding evidence.

1. Where is the subject? What could we call this kind of composition?

2. Do you have the feeling that:
 - the paraglider is more or less immobile in the sky?
 - the paraglider is moving? If it seems to be moving, which direction would you say it's going? To the left, to the right? Up, down?

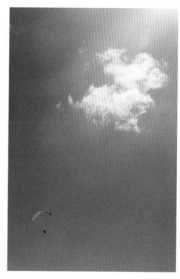

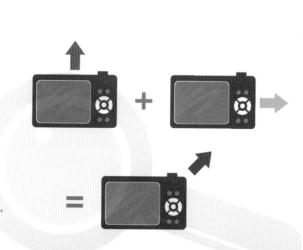

📓 Deductions. Triple space

When you position the subject in the corner of the picture, it's a little bit like moving it toward two edges at the same time. This time, for example, the paraglider is shifted to the left but also toward the bottom of the picture!

1. The subject is at the bottom left of the picture, in the corner. You could call this a "corner composition" or a composition "shifted to the bottom left."

2. The paraglider does not look immobile at all: it looks like it wants to move upward diagonally to go connect with the cloud!

Hmmm, so where am I going to put my starring subject?

This composition gives the paraglider room in front of it (to its right) and also above it. This gives it even more possibilities to "move around" in the picture! We can imagine it moving to the right, going up even higher in the sky, or even moving across the frame diagonally.

Strategy. The subject in the corner

Think about positioning your starring subject in the corner of the picture—that's often the best composition! This way the subject has lots of possibilities for moving within the frame, which makes the picture less boring and therefore more lively.

Most of the time, subjects are looking to the right or to the left, so you don't have a choice about which side to put them on. But in deciding whether to put them at the top or the bottom, you are generally free to put them either place.

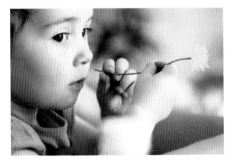

▶ The subject is in a different corner in each of these photos. Which of these subjects is not looking in a specific direction, allowing me to position it in any corner I liked?

The mushroom does not seem to be pointed in any particular direction; it's not looking off to the side like the yellow flowers on page 106. I could have put it in a different corner of the picture and my composition would have turned out just as nice!

Considering the evidence. Varied compositions

▶ Let's take a look at these pieces of evidence!

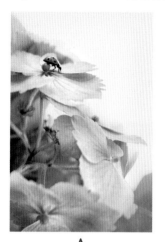

A B C D E

1. Where is the starring subject of each of these pictures?
2. Of the photos with the subject in the corner, which are successful pictures? Note: if there is a problem with the composition, then the picture is not successful.

1. A: the ladybug at the top left; B: the window at the bottom; C: the balloon, more or less in the middle, a little bit toward the top; D: the algae shaped like a miniature tree at the top right; E: the dog at the bottom right.
2. Pictures A and D are corner pictures that are well composed. Picture E is not well composed because the subject is too close to the edge; the dog's tail and one of its legs are touching the frame.

Now you frame it. Let's go back again

1. Place your frame on the view of the beach on page 107 and create two different compositions, each with the red sand sail under the gray sky positioned in a corner. (You could even find three different compositions!)

2. Use your frame to take a picture of the pony on page 103 that corresponds to this coded document:

Haha. I think we are going to have a new picture quest soon. I can't wait to take real pictures with the subject in the corner!!

Deductions. Photo compositions

These are the compositions that are possible showing the sand sail in a corner under the gray sky:

- a horizontal composition with the subject at the lower right;
- a vertical composition with the subject at the lower left;
- and a vertical composition with the subject at the lower right!

▶ Given the fact that the sand sail is moving to the right, and we want to compose in the direction of the gaze, which is the best composition?

Only the middle picture, with the sand sail at the left, is composed in the direction of the gaze!

Here is our new composition with the pony.

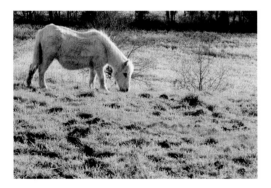

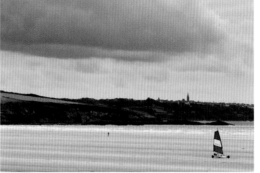

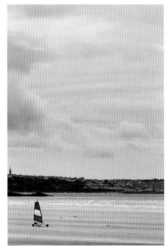

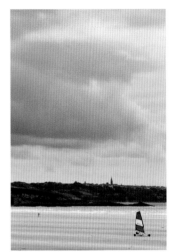

Wahoo, here we goooooo!

Picture quest. Decentered compositions shifted toward a corner of the frame

▶ Now you get to play around with decentered compositions! Here are your marching orders.

1. Find a subject that is pretty small or far away from you: an eraser, a piece of candy, a little stone, a flower all by itself, a house or a tree far away...

2. Make your subject move around in the picture by having it go from one corner of the frame to another. Move your camera around to make this happen, of course!

3. Figure out which corner your subject would look best in, depending on what you want to show around it, and whether it's better to give it room above, below, to the right, or to the left.

Let's investigate.

Adding compositions to each other!

▶ Let's talk in code again: it's more discreet that way!

1. What can you say about the composition of this picture?

2. What do the encrypted documents below it mean?

together.
2. The coded documents mean that this picture is made up of two compositions added
Another subject, the cloud, is corner-cropped.
1. The starring subject, the helicopter, is positioned in the corner of the picture.

Strategy. Multicompositions

When you take a picture of several interesting subjects at the same time, try to make sure that each subject has the benefit of good and thoughtful composition.

For example, position them in different corners of the frame (using corner framing or shifting toward a corner)!

When I am not sure how I should compose my pictures, I use my secret motto: "Corners are sharp!"

Considering the evidence. Flashback evidence

I went back to the earlier chapters and found new pieces of evidence for "additive compositions!"

▶ Look carefully at these three coded messages and find their corresponding pictures in order to refine your strategy!

Note that sometimes you will have to create the picture using your cardstock frame. Good luck!

page 15.
Message 3: This is photo B on
in the lower left.
right and the fish with the orange tail
corners: the striped fish in the upper
a picture with a fish in each of two
the aquarium on page 17 and take
position your cardstock frame on
Message 2: To get this, you have to
on page 63.
Message 1: This is the second picture

Are you ready for the home stretch?! Heh heh heh!!!

Our strategic photo-composition plan is, indeed, almost finished.
Cropping a large subject with the frame, positioning a small object within the picture: we are almost up to speed with that.

Now all we need to do is add "one more string to our bow!"

"The home stretch." That's like a straight line. I get it! I've already figured out what the end of the book is going to be about!!!

Or the trail behind a jet plane?

Yes, and "one more string to our bow"...A string, ha ha! And why not an electrical wire?

The riddle of lines

New subjects to compose

🔍 Let's investigate. Strange subjects

So, have we seen everything there is to see in terms of composition strategies?

▶ Let's see if we can find one of the types of composition we have talked about so far in this picture.

1. What can you say about the subjects of this picture? Are they large subjects? Small subjects?

2. Is the picture composed like the other ones we've already seen?

It's true, these are very odd subjects!!

1. The jet trail and the electric wires are not really either large subjects or small subjects. I would say that they are long subjects instead. They are thin and stretched out.

2. The composition does not look like the other ones we have looked at and studied!

Deductions.
Stretched out, elongated, tapered

Here we have yet another kind of subject! Electric wires and jet trails are thin, elongated subjects, a little bit like lines you might draw with a marker.

A line is not like a little subject: you can't just put it into the corner of the frame because it goes clear across the picture! But it isn't like a big subject, either, that you could crop a part of.

Since it's a different kind of subject, we will most certainly have to find a different way to compose our pictures!

Further investigation. The line in the water

The other day, I found a wavy line that I liked a lot.

It was actually the reflection of a rope in the water of a canal. Look at what I had fun doing with my subject when I found it!

▶ Look carefully at the photos.

1. What did I do with my line? What is the difference between the three pictures?

2. Would you know how to make pictures like these with your camera? Which secret weapon would you use?

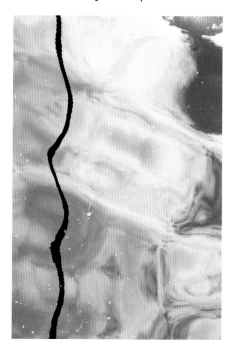
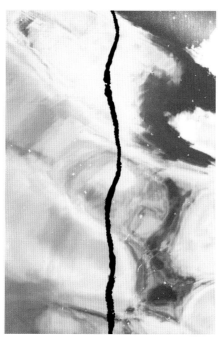
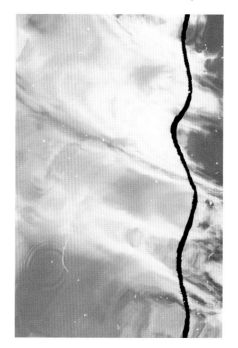

1. I had fun making the line move through the picture, first putting it on the left, then in the middle, and then finally it on the right.

2. Moving your subject around in the picture? Yes, of course, that's easy! All you have to do is move your camera around in front of the subject, and that makes the subject move around within the picture. It's secret weapon no. 1: moving the frame.

Deductions. Vertical subjects

It isn't possible to move a vertical line up or down.

So in deciding how to compose the picture, what you can do is move it from left to right!

Strategy. Moving vertical lines

We can move the lines in the picture by moving our camera, using secret weapon no. 1. When a line is mostly vertical, like a post or a tree trunk, your choice in composing your picture is whether to place the subject in the middle, to the left, or to the right!

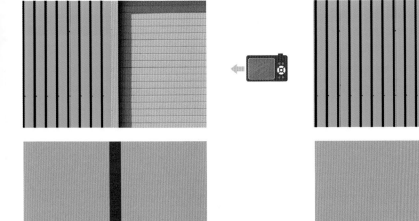

With this yellow line, which I found on the wall of a factory, I tried out two different compositions: I placed the line in the center, and then shifted it to the right!

> The line that is your subject can be very fine or a little thicker. Sometimes the line touches the frame on both sides as it goes across the picture, and sometimes it stops partway through the picture.

Now you frame it. Electric poles

▶ First, let's just go over what kinds of subjects we can see in this landscape out in the country.

1. Can you find one or more lines?

2. Is there a large, interesting subject that we could crop with the frame?

3. Is there a small starring subject in this picture?

4. Do you see any pesky intruders that we should deal with?

1. The poles and the electric wires are lines, and so are the horizon and the sides of the road.
2. There isn't a large, interesting subject that we could crop with the frame.
3. There is, however, a small starring subject: the little girl with her dog.
4. The car is a pesky intruder that we should try to keep out of our frame.

▶ Time for framing and composition challenges!

1. Put your frame on the book and practice moving the poles from right to left and from left to right within the picture. First use a vertical format and then a horizontal format.

2. Compose a horizontal picture with the poles on the left and a little bit of the field showing.

3. Create two compositions that correspond to these two coded documents:

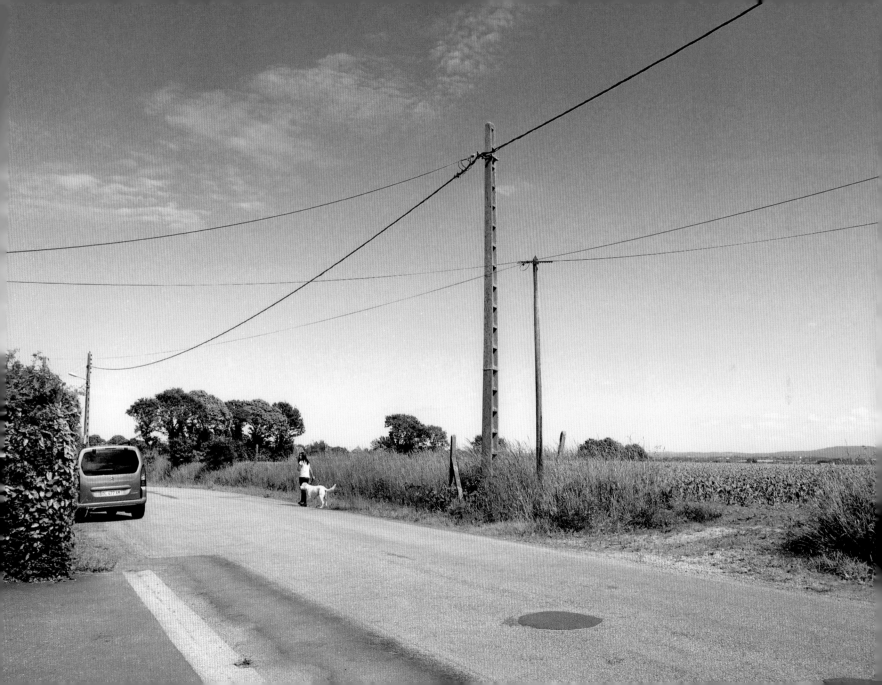

Deductions. Power lines

What cool pictures we can take here with the lines of the wires and the posts, the girl with the dog, and the lovely colors of the countryside beneath a blue sky as our subjects!

Here is the picture with the posts at the left and a little bit of the field showing. We had to cut off the top of the large pole in order to keep the field in the picture.

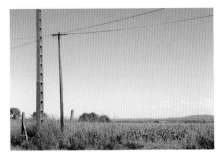

In the first coded document, the two vertical bands represent the poles and the thin diagonal line stands for the thickest electric wire. Isn't this picture full of lines pretty?

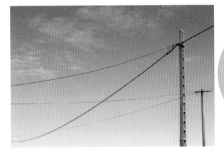

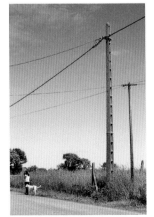

In order to decode the second document, you have to put the poles on the right and place our starring subject, the girl and her dog, in the lower left corner. Did you meet the challenge?!

Picture quest. The pencil as line

▶ A pencil is a thin, elongated subject, a little bit like a line!

1. Put a pencil or pen all by itself on a table or on the ground, vertically, in front of you. Then don't touch it! Your frame should move, not the pencil.

2. Stand above the subject in order to photograph it.

3. Take four pictures that correspond to these four coded documents.

If your pictures are blurry because you are too close and your camera can't focus, then choose a larger subject—for instance, a long ruler, a wooden kitchen spoon, or a stick.

The coded documents tell you where to put the pencil in the picture, whether or not it is cropped by the frame, and anything else you need to know!

Lines lying down...

It's not surprising that the "line of landscapes" is called the horizon! It is a horizontal line!

 Let's investigate! The line of landscapes

These two pieces of evidence should help us to find new clues about composing with lines.

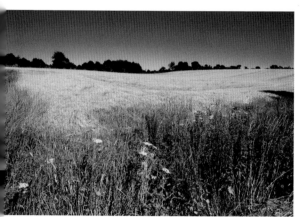

▶ Find what's true about the evidence!

A. There are no lines in these pictures.

B. The row of trees between the sky and the field makes a kind of dark line.

C. I moved my camera downward in between these two pictures.

D. I moved my camera from right to left in between these two pictures.

E. Changing the composition allows me to choose whether I want more sky or more field.

Sentences B, C, and E are true.

Strategy.
Moving subjects that are horizontal lines

When a line is mostly horizontal, like a row of trees in a landscape or an electric wire, it can be placed at the top, in the middle, or at the bottom of the picture.

Decide on the height at which you want to have the line appear in the frame to change the composition of the picture and what is shown in the photo!

121

Considering the evidence.

Keeping the line

Before we go on to the next thing, let's take a good look at these special pieces of evidence so that we can make sure we understand everything we've discussed.

These pictures have lines in them that are a little different from the ones we have seen so far!

▶ Once again, find the statements that explain the new evidence we can find in these pictures!

A. There is only one kind of line.

B. You can compose with several lines that together make up stripes.

C. A line can be twisted, waving, or deformed.

D. A colorful umbrella is also a line.

E. A line doesn't always have to be a specific element: the border between two surfaces—for example, between the sky and the ground or between the road and the grass—is also a line.

F. A line is always straight.

G. Elements that don't touch each other but that line up can form a line.

Statements B, C, E, and G are true.

A penchant for lines

🔍 Let's investigate. Tick tock

▶ Let's see how the line in these pieces of evidence acts. It's a fern branch.

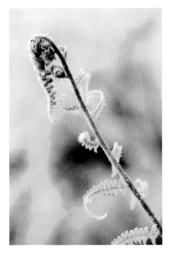 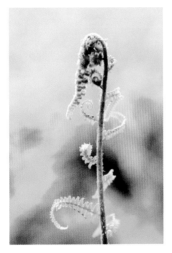 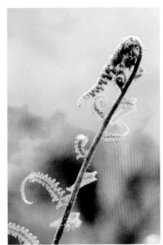

Tick tock—it's like the line is moving back and forth like the needle on a metronome!

Or like wind-shield wipers!

That's strange. I'm sure the fern didn't move; there was no wind.

1. So what do you think did move?

2. What kind of a movement was it? Doesn't that remind you of anything? Find the hint hidden on this page if you need to!

2. The camera swung around and tipped over to one side and then to the other. This is secret weapon no. 2.

1. The camera moved.

Hint: What do you need to do so that the subject tilts to the side in the picture? It's one of our secret weapons.

Deductions. Tilting the frame

In order to take these different pictures of the fern with the subject straight up and tilted to the side, I tilted the camera itself, of course!

Using secret weapon no. 2, you can choose to make a line tilt to the right or to the left! Yeah!

Strategy. Making lines lean sideways

Isn't it brilliant to be able to decide how much a line will be tilted, and in what direction? You can decide to put the line into the picture on a diagonal, or make it go along the frame, or position it in some other direction!

By tilting the frame, sometimes you run the risk of making yourself feel dizzy or seasick, as we know (see page 39), but it's still a very cool trick to use in composition!

> Okay, so to sum up, you can move a line around in the picture AND you can also tilt it however you like?! Fantastic!!!

In order to talk about how the line is tilted in the picture or whether it is tilted or not, you have to ask yourself about its "orientation."

For example, when I say that two lines are not oriented the same way, that could either mean that one is tilted and the other is horizontal or vertical, or it could mean that they are both tilted but in different directions.

Now you frame it. A line in the sky

Are you ready to tilt the frame to achieve your goal? We are going to play with this stretched-out jet trail running diagonally across the sky.

1. When you position your frame horizontally or vertically against the sky, is the jet trail horizontal? Vertical? Tilted?

2. Create the pictures that correspond to coded documents A, B, and C below.

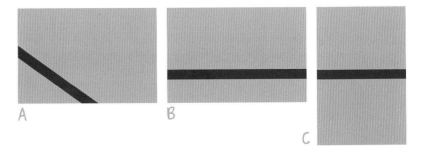

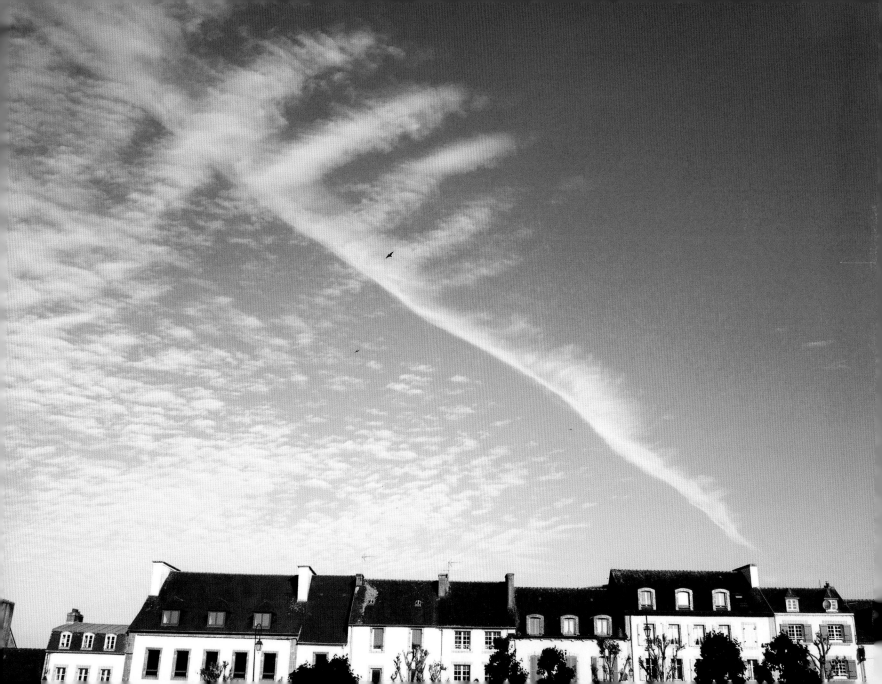

Deductions. Abracada...line!

In coded document A, the line is tilted the same way as the jet trail in the sky. All I had to do for this composition was hold the frame perfectly straight.

A

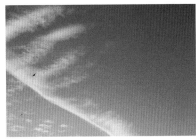

Then, in order to make the jet trail lie "flat" in picture B, I had to tilt the frame so that its bottom and top edges had the same tilt as the line. Shifting the frame could also help us to position the jet trail at the bottom of the picture.

B

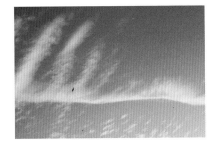

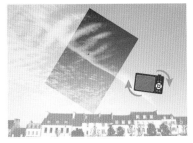

C

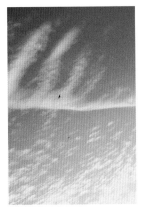

For picture C, it was sort of the same thing, but with a kind of "vertical tilted framing." I had to work things out so that the line would go through the middle of the picture.

Picture quest. Tilted lines

▶ And now, go get your camera!

1. Find a line in your house—for example, an electrical cord, the leg of a chair or table, the banisters on a staircase, the molding over a door...

2. Now have fun moving AND tilting your line in the picture in different ways. Of course, you can't touch the subject itself!

3. Take the picture when the composition looks most appealing to you.

Ha ha, another photographic joke! Because the jet trail is diagonal, it is tilted in the frame when the camera is straight...

...but you can make it straight in the frame by tilting the camera! That's really something!

Lines in perspective

Let's investigate. The line of the road

While I was taking these pictures, I was paying attention to the direction of one of the lines—always the same one—while using one of our secret weapons. I encrypted my observations so that they would remain **confidential**!

▶ Now it's your turn!

1. **Connect** each picture to its corresponding **coded document**.

2. **Which line** was I studying? Run your finger along the line in each picture in order to find it if you need to.

3. What is the **orientation** of the line in each picture? Do you think I **tilted the camera** to get these results?

4. Which of the secret weapons allowed me to change the direction of the line here?

1. A2, B3, C1.

2. The line that I was studying is the border between the road and the grass.

3. The line is horizontal in picture A; diagonal in picture B; and vertical, straight up and down, in picture C! And yet, it doesn't look as though the camera was tilted: the landscape still looks normal, and so does the house. 4. I used secret weapon no. 3, the three-dimensional weapon! I got closer and closer to the line and turned my body in order to change the direction of the line in each picture.

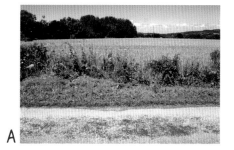

A

1

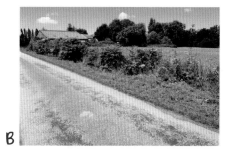

B

2

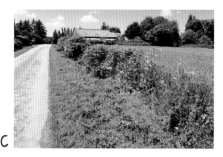

C

3

Hint: Do you think my feet were always in the same place on the road?

127

Deductions. The weapon of the three dimensions in the service of composition

Who would have thought it? **The secret weapon of the three dimensions ALSO allows us to choose the orientation of a line in a picture!** Just by **moving farther away from or closer to a line,** you can **decide whether it will be horizontal, diagonal, or vertical,** and **make your composition better** that way. It's **crazy!**

Strategy. Orienting with your feet

This **strategy will help you to become a master of the lines!**

This technique works with lines that are lying down (**horizontal lines**)—a line drawn on the ground, the edge of a table, a shelf, the guardrail on a bridge—but **NOT with vertical lines,** like poles or tree trunks.

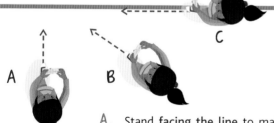

A. Stand **facing the line** to make it appear **horizontal.**

B. Stand **pretty close** to the line and rotate your body slightly. Now the line will look **diagonal** in the picture.

C. Stand with **your feet right on the line** (or on an imaginary line extending out from it) and rotate your body some more so that you're looking at the line **along its axis.** Now it will be **vertical!**

128

Picture quest. Taming the lines

▶ Now it's your turn to **tame a line on the ground!**

1. **Decide which line is going to be your main line.** I chose the edge of a rug, but you could also use a board in a wooden floor, the edge of a garden walkway, a sidewalk, a road, a path...

2. **Walk away from the line, walk up closer to it,** or even **turn in place, without losing your sight line!** Notice **the direction** of the line in the frame while you are moving around, as well as the **composition** of your picture. Always keep your camera nice and straight, with either a horizontal or a vertical format. **It's your feet that should move, not the camera!**

3. Try to take pictures in which **your line is horizontal (A), diagonal (B),** and **vertical (C)** just by moving around!

> *Watch out for cars!!! Never take pictures from the road. Stay on the sidewalk or on the side of the road.*

 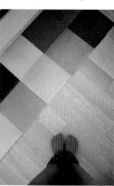 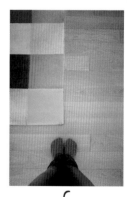

A B C

If you have **trouble creating the composition that you were imagining,** then at the very end, you can use **secret weapon no. 2** just a little! Tilt your camera slightly, if necessary, so that **the line is going in the direction that you want it to.**

Considering the evidence.

Under the bridge

Here are three new **pieces of evidence** so that we can **confirm our conclusions.**

▶ The photographer who took these pictures made the following **statements.** But watch out, this **sly person** does **not always tell the truth!** Find the **lie** that is hidden among these declarations.

A. It was **gorgeous weather** that day.

B. All of a sudden, I saw this **enormous bridge**— very impressive! I **took a picture of it from far away,** and then I got **closer.**

C. First, the **top of the bridge** looked **horizontal** in my pictures, and then it started to **tilt in the frame.**

D. The **line between the field and the bridge** started to **tilt** too, but in the other direction!

E. Finally, I used a vertical format so that I could **get a good picture of this very tilted line.**

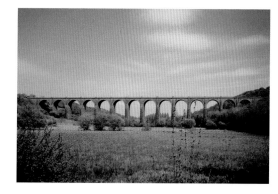

Further investigation. What do you feel?

▶ Let's **investigate** the pictures of the bridge a little further. Of the three pictures here, which ones seems:

1. the **calmest and most restful** to you?

2. the **most lively and dynamic** to you?

Sentence D is a lie. The line between the field and the bridge does not change its orientation. It doesn't tilt at all! It is horizontal in all of the pictures.

The first picture, which shows the bridge from far away and in which all the lines horizontal, is the calmest and most restful. The third photo is the most dynamic one. You could almost imagine a train going across it at top speed!

129

Lines give **personality** to our pictures. It's true!

Horizontal lines are gentle, calm, restful lines. A picture that is full of horizontal lines is **like a view of the seaside on vacation.** It makes you feel like **relaxing in the sun.**

> I like to let myself be rocked by the gentle horizontal lines.

Tilted or diagonal lines are lively, dynamic, and expressive. A picture that is full of diagonal lines is **like a train zooming across a bridge or through a tunnel at top speed!** It sounds like it's saying "whaaaaaow!"

> Diagonals just give me so much energy!!! What a boost!!

So then what about **vertical lines**? Well, they are **between the two: less restful** than horizontal lines but **less dynamic** than diagonals! They make us think of **a forest filled with trees stretching toward the sky.** They make us want to **look up and stretch upward** too, to try and **touch the clouds.**

Isn't it **great** to be able to **choose how to orient the lines in your pictures**, using your **high-tech weapons no. 2 and no. 3**? This way, you can **decide** whether you want your **picture** to be **calm and restful** or **lively and dynamic!**

 Picture quest.
Off to find lines

▶ Hunt for lines all around you. You will see that they are EVERYWHERE. It's absolutely crazy!

1. Take a **calm, restful picture**, showing mostly **objects that are lying down and horizontal lines** piled up one on top of one another.

2. Now take a **picture showing vertical lines** arranged sort of like **bars rising toward the sky.**

3. And finally, take **a dynamic picture with tilted lines!** Try to position the **main line** on an **exact diagonal** right across your picture.

Lines and the frame

A

B

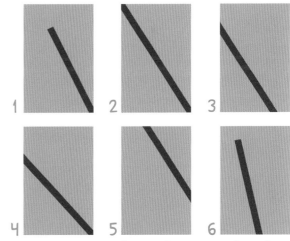

C

D

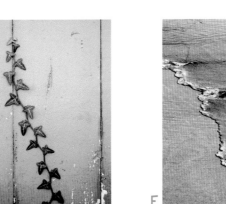

E

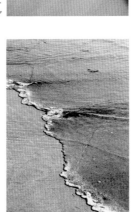

F

Let's investigate.
Twin compositions

Let's push our investigation even further and explore the lines in our pictures down to their tiniest details.

▶ These pieces of evidence are similar in their compositions, wouldn't you say?

1. What do all these pictures have in common?

2. And yet, when you look a little closer, each picture does have a different composition! To help you find these differences, connect each photograph to its corresponding coded document.

3. What did you notice, in particular, in these pictures to help you meet this challenge?

1 2 3

4 5 6

3. It helped to notice that the line touches the frame in different places: in the corner or at the edge, and in a specific place on the edge or in a particular corner.

2. The pairs are A3, B1, C5, D2, E6, and F4.

1. The lines in these pictures are all tilted diagonally. They are all leaning in the same direction.

Deductions.
Entrance and exit

Depending on whether a line enters the picture along the edge of the frame or in a corner, the result is quite different! The composition also changes depending on where the line leaves the picture.

Sometimes the line ends within the picture, and sometimes it goes clear across the picture.

Strategy. Points of contact between the line and the frame

For a good composition, decide whether your line is going to touch the frame in the corner or on the edge (and also in which corner or at what point on the edge).

Using all of your brilliant secret weapons, tilt your line in the picture however you want and make it connect to an edge or a corner, whatever you prefer!

Do you remember what we said?! "Corners are sharp!" So whenever you're not quite sure, make it so that your line touches one of the corners of the frame to compose like a pro!

Picture quest. Going line fishing

▶ Here is your new assignment.

1. Find a line to photograph.

2. Frame it in such a way that the line goes completely across the picture. It should touch the frame in two places.

3. Use your three secret weapons to create the following compositions:

– The line goes from a short edge to a long edge of the picture.

– The line goes from one corner to a short edge of the picture.

– The line goes from the middle of a long edge to one of the corners of the picture.

Considering the evidence. Framing tiles

In composing these pictures, I was particularly careful about the orientation of the band of zigzag light-yellow and black tiling.

▶ Look carefully at these pieces of evidence.

1. In these pictures, the main line touches the frame in two places. Which ones?

2. Do you know what we call this kind of line?

3. Does the line have the same tilt in the horizontal photo and in the vertical photo?

1. The line touches the frame in two of the corners: the lower left corner and the upper right one.
2. A line that connects one corner to another like this is called a diagonal line.
3. The diagonal has a gentler slope in the horizontal photo. In the vertical photo it has a steep slope, which makes the picture look more dynamic!

 ## Now you frame it. The line of the sky

Place your frame on the picture of the sky on page 125 and create the following compositions:

1. A vertical picture without the bird but with the jet trail touching the lower right corner of the frame.

2. A horizontal picture with the jet trail going diagonally across the frame: the line has to touch the top left corner AND the bottom right corner of the frame!

Once you have created these pictures, you can turn the page if you'd like to see the answers before going on to the picture quest below.

Picture quest.
Looking for corners and diagonals!

▶ Get your camera!

1. Look for lines around you again.

2. Make a composition in which your line touches at least one corner of the frame. Move your camera and your body around to make this happen! Don't forget your secret weapons!

3. Will you be able to meet the challenge of the diagonal?! Take a picture with a line going across the frame from one corner to the other!

Well, well, it seems that diagonal compositions are the best compositions!! But don't tell anybody, whatever you do!

Deductions. Dreamy compositions

Here are the two pictures I took for the "Now you frame it" challenge on the previous page. For these compositions, you could keep your frame straight or tilt it—whatever you like!

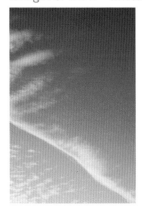

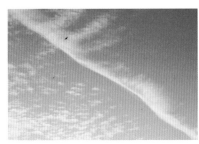

Now you frame it. The final challenge, with seven compositions

Are you ready for the final challenge, which will allow you to complete your mission? It is the ultimate stage in solving the mystery of photography!

Carefully create the seven compositions described here using your cardstock frame on the scene with the boat.

If some of the compositions seem hard, don't give up, and don't look at the answers right away!

1. A horizontal picture with the boat's anchor in the top left corner.

2. A picture with the rope on a diagonal across the picture (it has to touch two opposite corners of the frame).

3. A picture in which the body of the boat is positioned according to coded document A.

4. A vertical picture showing the man in the corner, composed in the direction of his gaze.

5. A picture without the boat in it! Not even any tiny piece of the boat! (However, if there is a piece of rope in the picture, don't worry about that.)

A

6. A composition corresponding to coded document B. This shows you where the rope and anchor should be in the picture.

7. A horizontal picture showing the man at the top of the picture and the rope touching the bottom left corner of the frame.

B

When you believe that you have solved all seven compositions in this puzzle, turn the page!

A good strategy is to go back through this book to find helpful information, hints, and examples of pictures that are like the ones you need to put together here...and keep at it!

You CAN do it!

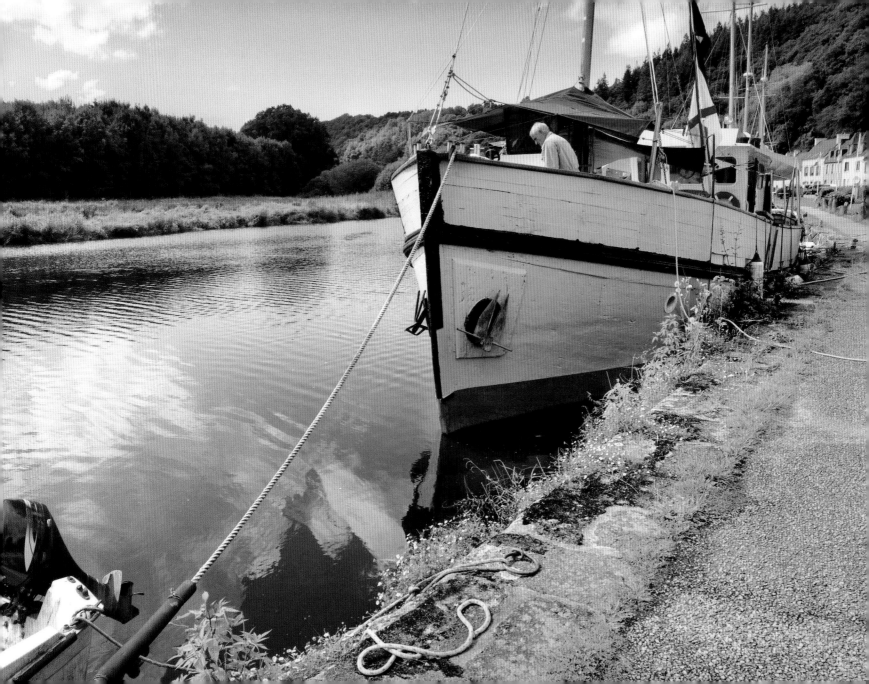

Here are **the answers to the final challenge**. As always, if your pictures are **not exactly like mine** but **still meet the requirements**, then of course that's fine.

1. A horizontal picture with the boat's anchor in the top left corner

A **blue boat** and **green grass**—isn't that pretty?! And the **anchor catches our eye**.

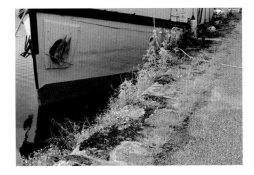

2. A picture with the rope running diagonally across the frame

I made two compositions: a **vertical one with the frame straight** and a **horizontal picture with the frame tilted**. Which one did you find?

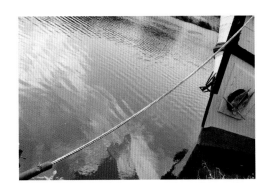

3. A picture with the body of the boat matching this coded document

This is a **corner frame of the body of the boat**. I really like **the ropes twisting around** in the foreground!

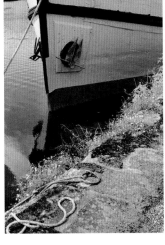

4. A vertical picture with the man in the corner, composed in the direction of his gaze

I put the man **in the top right** corner of the picture, of course, so that he would be **looking into the picture!**

5. A picture without the boat! Not even a tiny piece of the boat

This was only possible using a **vertical format**.

7. A horizontal picture with the man at the top of the picture and the rope touching the bottom left corner of the frame

After I put the man at the very top of the picture, I slid my frame carefully along the book until I had the rope right in the corner!

6. A composition with the rope and the anchor, corresponding to coded document B

I had to **tilt my frame** to get the rope to go **across** the picture this way. Then I **shifted the frame** so that the rope is **in the middle** and the anchor is **in the corner**.

So did you meet the challenge? My sincere congratulations! You are a real champion, a composition pro!

I therefore have the great honor today of declaring you a "Graduate Knight in Photo Composition" and a "Young Photography Expert!" Again, GOOD FOR YOU!

To celebrate, choose the three pictures you like best of all of the ones you have taken since you started working with this book and ask your parents to print them or order prints.

Then hang them up in your room. That's right, good photographers have their pictures displayed on the wall and you have a right to that now too!

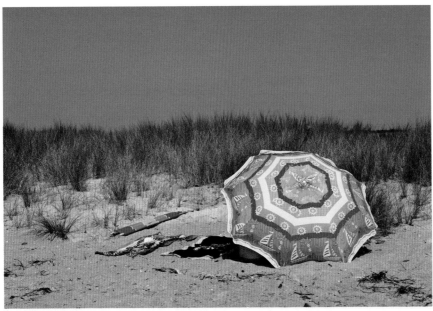

The mission continues!

What a lot of clues and strategies we have discovered for learning how to use these secret weapons with their amazing possibilities! Photography definitely has a lot of surprises for us, wouldn't you say?!

And you met the challenge and fulfilled your mission with such enthusiasm! I have been following all of that from the other side of this book and I can truly say that I am very proud of you. These mysteries that you have resolved, these pictures that you have created, are all that was needed in order for photography to get a new lease on life. A new lease signed by you, the young photographer, of course!

I do believe that thanks to you and your friends, photography is now young again. Thank you.

All through this book, you have observed photographs and scenes to be photographed in order to better understand how to make the things, people, and places around you into beautiful images. Now, whenever you look around you, whether at home, at school, on the street, or out in nature, you will surely find subjects to photograph, and even pesky interlopers to avoid. You won't be able to help it!

Thanks to your secret weapons, you will be more and more able to take pictures the way YOU want to.

It's true that in this book I was often the one giving you instructions (for example, "put the subject in the corner of the picture"), but when you have the camera in your hand, it is you and only YOU who gives the orders and chooses the compositions to create!

YOU are the one who decides "what it would be good to do," as well as the one who really takes the pictures.

And so I encourage you now to think about framing and about the composition of your pictures exactly the way we have been doing it together!

I am counting on you to keep working to solve the mystery of photography, day by day, because even though you have already discovered an enormous number of things, I am going to tell you a secret: every new picture that we take allows us to learn even more!

All that I want is for taking pictures to make you happy and curious and to help you appreciate what is around you. On the days when you don't feel inspired, think about the fact that even when it's raining, you can take fabulous pictures! That even garbage cans can be cool subjects! That even a rusty sign can lead us to marvel and wonder. So now it's up to you to frame, to compose, to photograph!

Thank you, young friend, for taking up the torch of photography. Thanks to you, and all photographers small and large, photography will continue to grow and spread, along with those who practice it, of course.

Well done!

Anne-Laure Jacquart.

TOP SECRET

Thank you!

It was great carrying out this mission together. Thank you!

First, I would like to thank the adults who have been trying to solve the mystery of photography along with me for several years now. Thanks to them for having opened up the road for the kids and prepared the way!

My thanks as well to éditions Eyrolles and to my editor, Hélène Pouchot. She is my writing companion and worked hard at my side so that this book would be just right! Magalie, Marion, and Damien took care of the page layout and Thomas made great, appealing drawings. Thank you, everyone!

I would also like to thank the person who gave you this book, without whom you would not be bursting with your picture-taking! Thank you to that person for having chosen me to pass on our shared passion for photography. It's fantastic that that person thought of you for carrying out this important mission!

And finally (haha, I kept the best for the last!), I want to thank YOU for having dared to launch yourself into this adventure and to love photography as much as I do. Thank you for creating beautiful, funny, magical, strange, and fabulous pictures that make the world a little more beautiful.

To everyone, THANK YOU!

Anne-Laure